Remembering
Baltimore

Mark Walston

TURNER
PUBLISHING COMPANY

T0143634

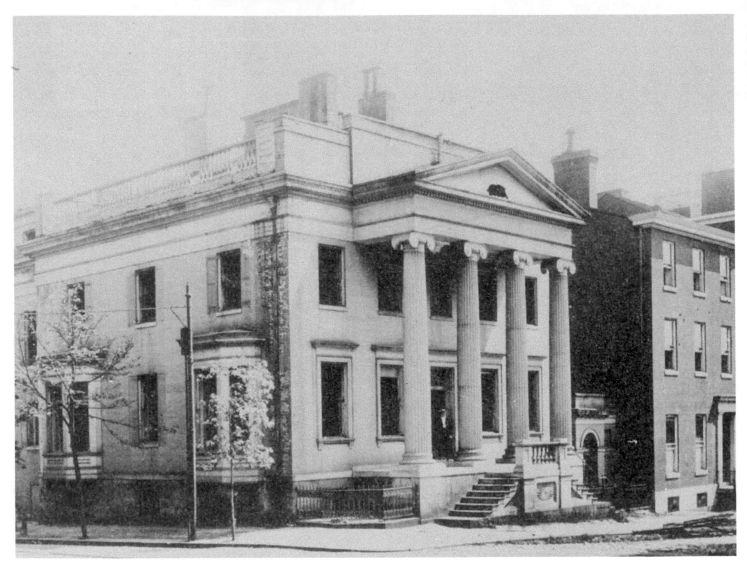

The Baltimore Athenaeum Club, an association of the city's elite formed to promote literary and scientific learning, claimed as its home the residence of William Howard, constructed between 1828 and 1830 at the intersection of Charles and Franklin streets. Howard was not only a noted physician, but also a natural historian, engineer, surveyor, and amateur architect who traveled the world seeking history's great buildings. He hired architect William Small to design his classically inspired residence, with its heavy, pedimented portico supported by four columns.

Remembering
Baltimore

Turner Publishing Company
www.turnerpublishing.com

Remembering Baltimore

Copyright © 2010 Turner Publishing Company

All rights reserved.
This book or any part thereof may not be reproduced or transmitted
in any form or by any means, electronic or mechanical, including
photocopying, recording, or by any information storage and retrieval
system, without permission in writing from the publisher.

Library of Congress Control Number: 2010932273

ISBN: 978-1-59652-699-0

Printed in the United States of America

ISBN: 978-1-68336-809-0 (pbk.)

CONTENTS

The beginnings of architectural cast iron, which experienced nationwide popularity in the mid–nineteenth century, had strong Baltimore connections, due in part to the existence of a number of ironworks already operating around town. The Gilmore House, built about 1840 and later known as the St. Clair Hotel, decorated Monument Square by its addition of an elaborately ornamental, two-story cast-iron front, seen here in 1894.

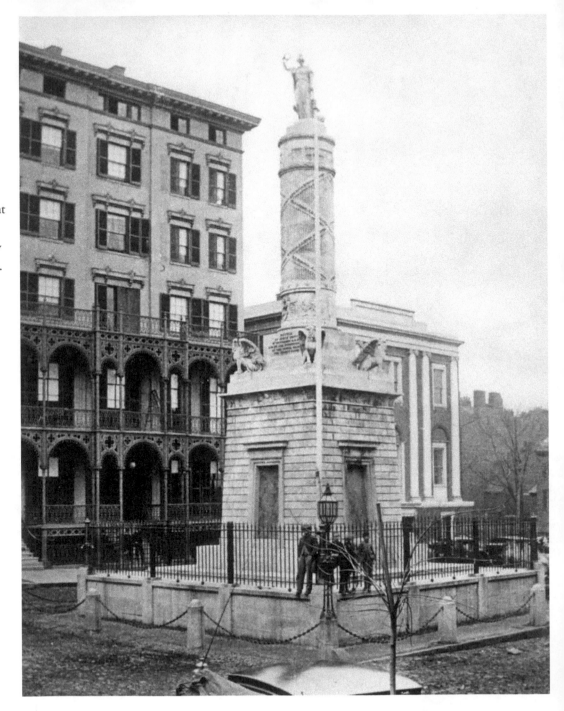

Acknowledgments

With the exception of cropping images where needed and touching up imperfections that have accrued with the passage of time, no changes have been made to the photographs in this volume. The caliber and clarity of many photographs are limited by the technology of the day and the ability of the photographer at the time they were made.

This volume, *Remembering Baltimore,* is the result of the cooperation and efforts of many individuals and organizations. It is with great thanks that we acknowledge the valuable contribution of the following for their generous support:

Baltimore Camera Club
Baltimore Museum of Industry
Enoch Pratt Free Library, Central Library/State Library Resource Center, Baltimore, Maryland
The Frances Loeb Library, Harvard Graduate School of Design.
Library of Congress
The New-York Historical Society

PREFACE

Every day, the average American is exposed to hundreds of photographic images, in newspapers, magazines, books, advertising, Web sites—photos both publicly displayed and privately shared among family and friends. Photographs inform us of occurrences around the world. They capture personal moments. They illustrate, identify, educate, entertain, inspire. They show us the distant reaches of the universe and the smallest particles of life.

From its beginning in the 1830s, when the French painter and printmaker Louis-Jacques-Mandé Daguerre first discovered a chemical method to fix an image on a sheet of highly polished, silver-plated copper, photography radically changed how the world saw itself. Now there was a scientific method of showing rather than describing, a means of presenting life as it is, rather than filtering it through painting or drawing. "A mirror with a memory," early admirers called it.

Some may argue how much of a mirror photography truly is, whether it accurately reflects reality or is more a display of the photographer's personal bias—the subjects posed, positioned, manipulated, cropped to suit a particular idea or intention. As a historical record, however, photography provides a resource of inestimable value to anyone attempting to decipher a society at a particular point in time. It may not present a complete picture, but it provides details unobtainable in other references and, when combined with the written historical record, significantly enhances our understanding of the past.

In the beginning, photography was a specialized endeavor, reserved for a handful of artisans with the wherewithal to purchase equipment and supplies and the knowledge of how to produce the images. As a result, daguerreotypes, the earliest form of photography, were reserved for portraiture of the well-off—stiffly posed because of the length of time the subject had to stay still—or for capturing important landscapes or structures in the man-made environment. John Plumbe's 1846 daguerreotype of Baltimore's Battle Monument reflects photography's early emphasis on the significant rather than the mundane. Other methods of processing would appear over the next decades, from glass plates to the tintype, patented in 1858, which substituted a less costly iron plate. Traveling tintype photographers now could

conduct business out of the backs of wagons, taking pictures—for a price. The portability of the process expanded the range of possible subjects, while its relative inexpensiveness widened its accessibility.

By the 1880s, further improvements in processing would bring about a revolution in photography, and finally put a camera in the hands of the masses. George Eastman would devise a flexible alternative to the cumbersome photographic plates and toxic chemicals then in use: a thin strip of paper to which dry gel had been applied—the first practical film. Then, in 1888, Eastman's Kodak camera appeared, so simple that it did away with the specialized knowledge required to take a photograph. The user just pushed the button and left the complex process of developing the image to others. In 1901, with the appearance of Eastman's inexpensive Kodak Brownie, the era of popular photography began in earnest.

Technical advances during the latter part of the nineteenth century, as well, made it possible for photographers to clearly capture moving objects, allowing a greater spontaneity, producing on-the-spot photos of fast-breaking events. The series of images of Baltimore's Great Fire of 1904, taken just after fire fighters responded to the first alarm and documenting the spread of the fire minute by minute, provides a remarkable record of the catastrophic event. With a camera in every hand, photography became no longer the province of the few, and the photos taken began to reflect every aspect of life, the common as well as the extraordinary. A steamship docking at a pier, a policeman directing traffic, shoppers at the market, a woman scrubbing the stairs of her row house—all these familiar sights of everyday life in Baltimore were now recorded, preserved in photo albums, and made available for viewing far into the future.

Advances in reproduction technologies, in particular the development of the halftone printing process in the 1890s, also allowed these photographs to be inexpensively shared through the pages of newspapers, magazines, books, and more, thus expanding their use as a means of telling stories to the wider public. Photojournalist Lewis Hine would turn to photography to show the public the working conditions of some youth in the first decades of the twentieth century; his images of Baltimore children toiling in canning factories and picking fruit on area farms would become a leading impetus for enacting laws to prohibit the practice.

The advent of digital cameras further extended photography's reach—history has yet to determine whether the ephemeral nature of pixels on a screen will be preserved in any readable form, if saved at all for future generations to view and ponder. The images presented on the following pages, however, represent the early days when a photograph was a physical object—and by their reproduction in this book they are a tangible record, however partial, of nearly one hundred years of life in Baltimore.

—*Mark Walston*

In 1784, a new denomination was born in Baltimore: the Methodist Episcopal Church. Organized in a humble log structure known as the Lovely Lane Meeting House, the congregation by 1797 had grown to the point where a larger meetinghouse was wanted, and so a new church was constructed, fronting Light Street. Seen here in an 1860 view—taken before the building's demolition about 1872—the simple, unadorned structure adhered to the desire of those first Methodists to avoid the ostentation that marked many of the city's churches.

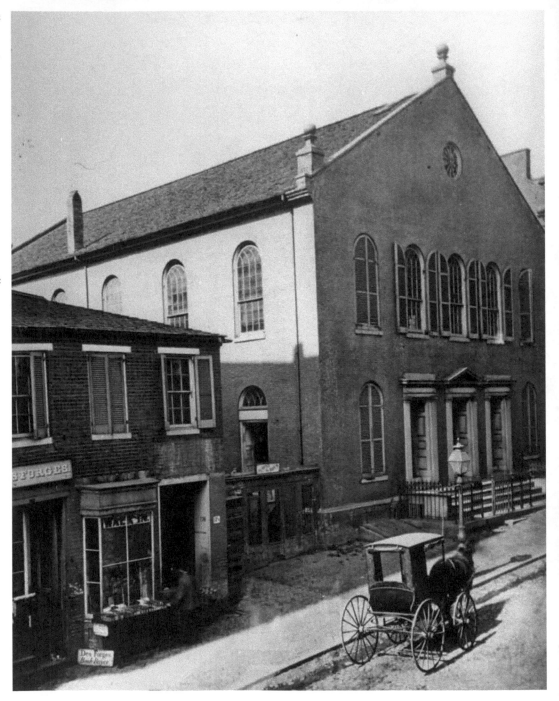

THE RISINGEST TOWN

(1860s–1903)

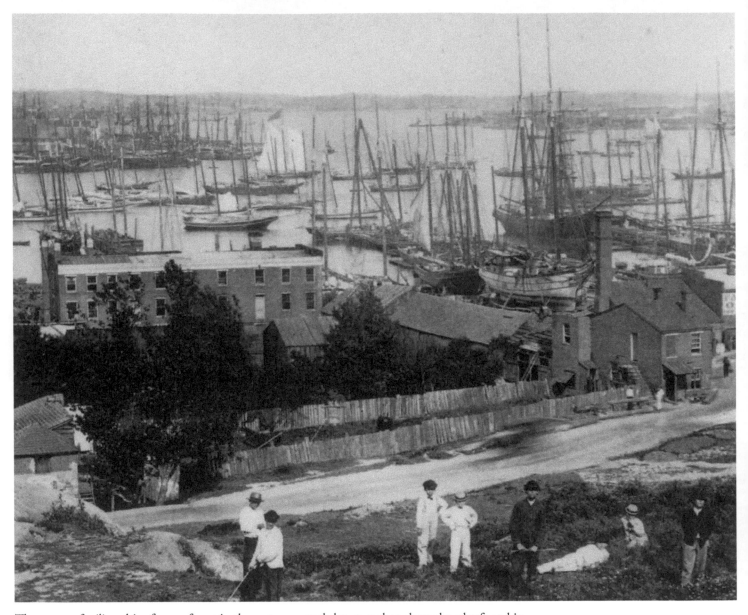

The masts of sailing ships form a forest in the water as vessels lay at anchor along the wharfs and in the harbor, seen here in a Baltimore view taken about 1870 from Federal Hill, south of the city center, looking east toward the Chesapeake Bay.

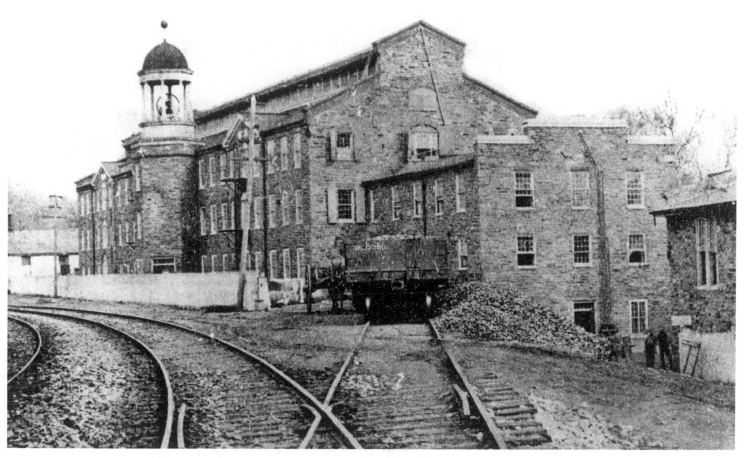

By the mid–nineteenth century, Baltimore had become one of the nation's leading centers of textile manufacturing, with dozens of cotton mills springing up around the city, availing themselves of a ready supply of moving water for power. Impressively, Baltimore's mills, including the Mount Vernon–Woodberry mill seen here, accounted for about 80 percent of the world's cotton duck production. A precipitous decline in demand after World War I—and a series of workers' strikes—sent the mills into decline, and by 1925 many had abandoned Baltimore for the lower costs of operating mills farther south.

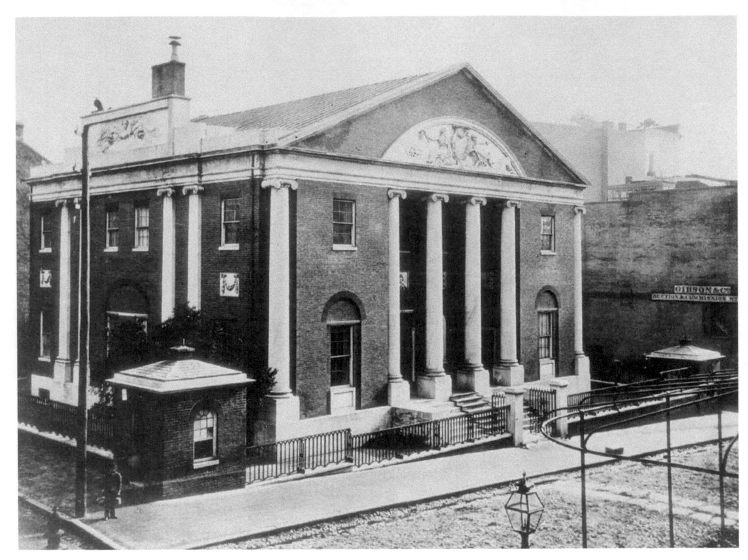

In 1804, the Union Bank of Maryland was organized and chartered, and by 1807 it had built this spacious banking house on the southeast corner of Fayette and Charles streets. Designed by architect Robert Carey Long, Sr., the bank was his first public structure and featured such classical elements as Ionic columns, marble pilasters, and the first figural sculpture to decorate a Baltimore building. The sculpture was carved by the Italian artists Giovanni Andrei and Guiseppi Franzoni, whom Baltimore architect Benjamin Henry Latrobe had brought to America to work on the Capitol in Washington, D.C.

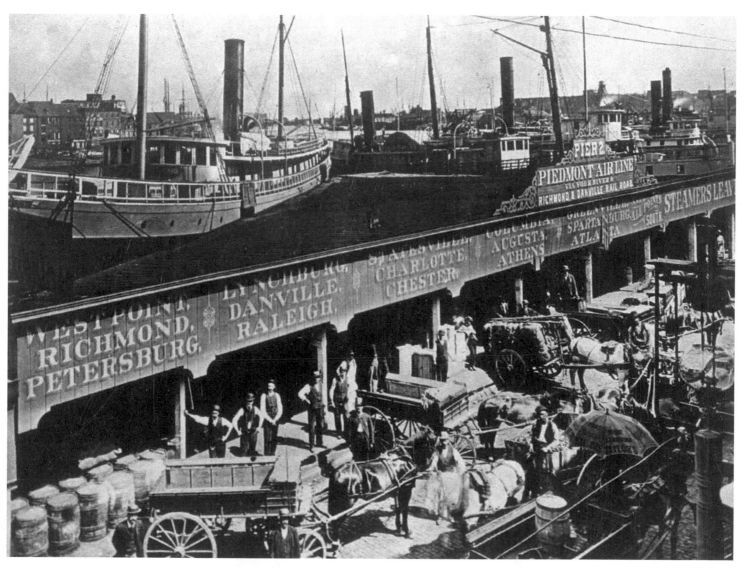

Pier 2, along Light Street, supported a broad range of commercial and industrial enterprises during the nineteenth century, not the least of which was the terminal of Piedmont Airline, which provided steamship connections between northbound and southbound passenger trains, in particular the Richmond and Danville line, a complex system of railroads encompassing 3,000 miles of track that stretched from Virginia to Texas. Railroads crisscrossed the city's waterfront—although, for safety reasons, steam-driven passenger trains were drawn to the piers by strings of horses or mules.

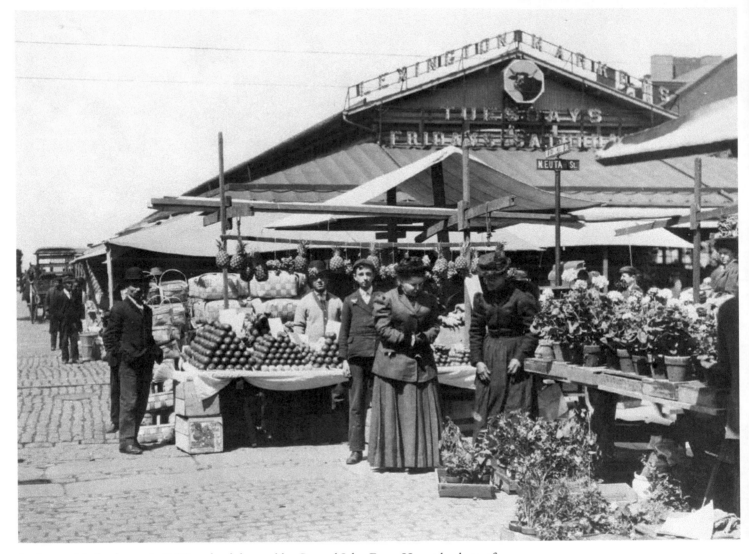

Lexington Market began in 1782 on land donated by General John Eager Howard, a hero of the American Revolution. Quickly the open-air market—patriotically named for the Battle of Lexington—became an important center for local commerce. A convenient place for area farmers to peddle their wares—hams, eggs, butter, vegetables, fruits, flowers, and more—the market also attracted merchants who gathered to barter and purchase grain, hay, farm supplies, and sundry other staples. In 1803, sheds began to be constructed on the site to protect the produce from the elements.

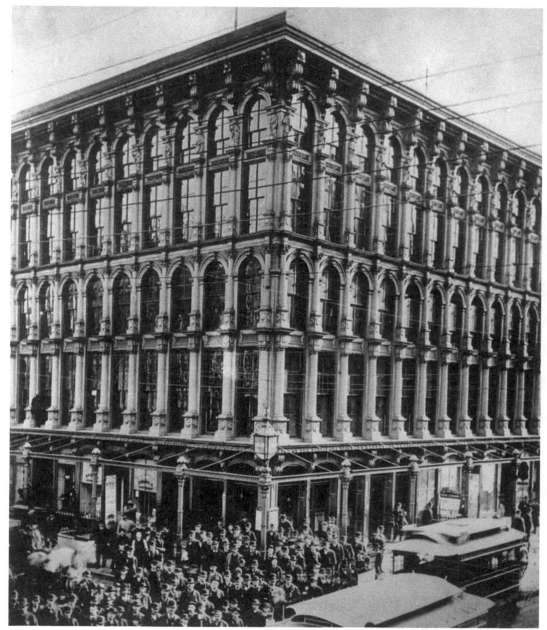

In 1837, Baltimore's growing presence on the national stage caught the attention of a journeyman printer from Rhode Island by the name of Arunah Shepherdson Abell, who decided to relocate to the city to try his hand at establishing a newspaper. Within a dozen years the paper, named the Sun, had grown into the most important publication in the city. In 1850, Abell engaged New York architect R. G. Hatfield to design a building better befitting the paper's status. Notably, the building, completed in 1851 and seen here some years later, featured a cast-iron front, thought at the time to be not only stylishly ornamental but thoroughly fireproof.

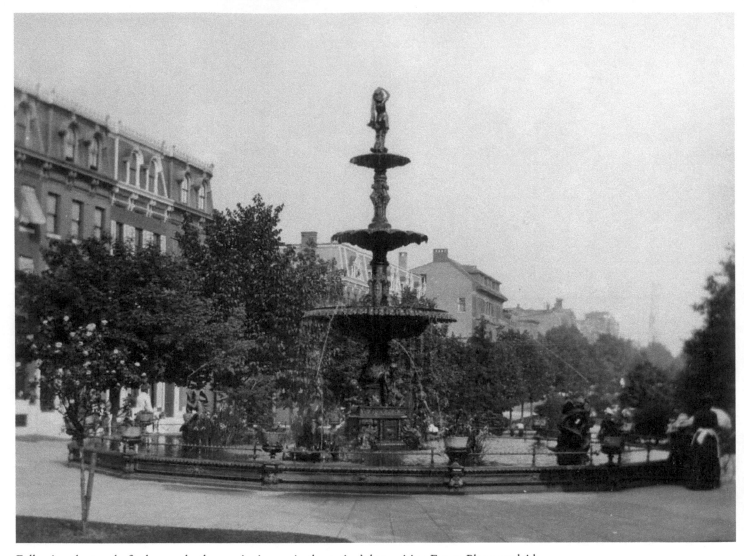

Following the trend of urban parks then springing up in the nation's large cities, Eutaw Place was laid out in 1856 as a trio of grass "places," providing an attractive view for the new blocks of fashionable houses going up along Eutaw Street. In 1880 the decision was made to extend the street with new green spaces up to North Avenue, creating a broad promenade. Eventually, Eutaw Place would present an amiable mix of sculptural landscaping, winding paths, and formal fountains, such as this one viewed about 1890.

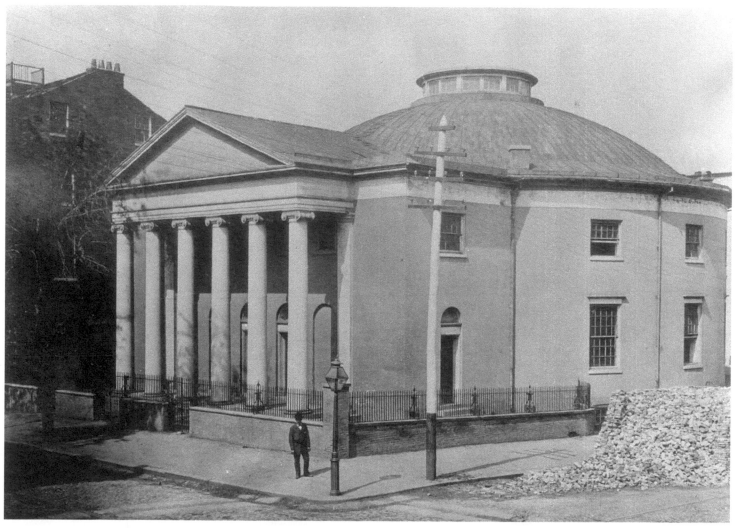

In 1817, Robert Mills, one of early America's most prolific and influential architects, designed the classically derived First Baptist Church. Completed the following year and majestically occupying the corner of South Sharp and Lombard streets, the church's central and most impressive feature was its great, laminated rib dome, inspired by the Pantheon in Rome, which soon garnered the church the affectionate nickname "Old Round Top."

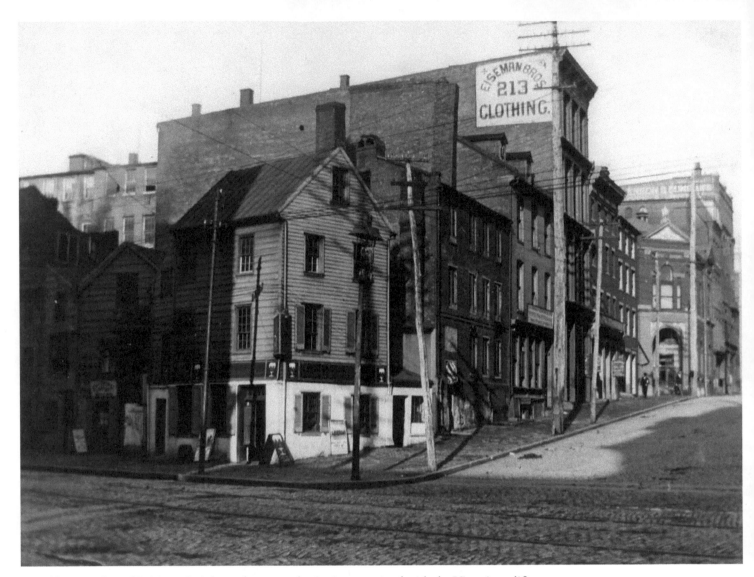

Humble reminders of Baltimore's eighteenth-century beginnings coexisted with the Victorian edifices of the nineteenth century, bringing a certain charm and visual delight to the city streets. Seen here in 1894, this building at the corner of Liberty and German (later Redwood) streets anchored a row that displayed the city's various architectural periods, from the wooden homes of a colonial village to the brick and iron of a major metropolis.

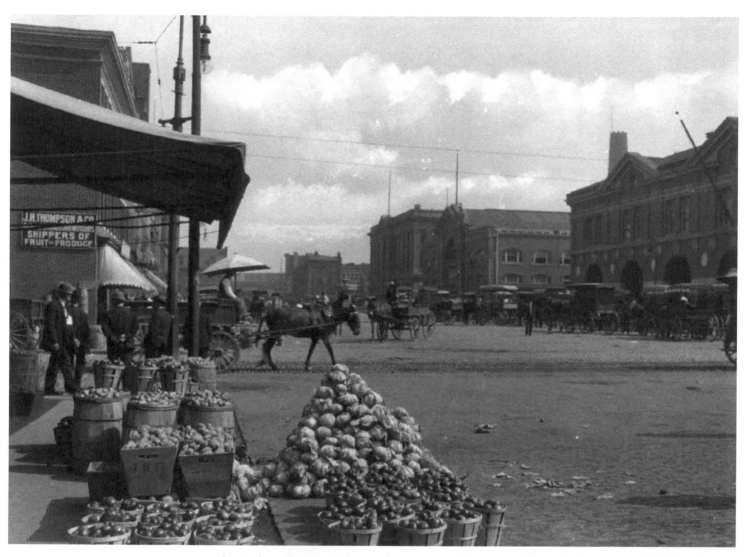

Situated on Harrison Street on the bed of an old swamp, Center Market was established in the mid eighteenth century as one of three principal marketplaces in the city. In 1784, construction began on a long, broad-roofed market house supported by brick piers. Over time, the building would be enlarged and improved and, by the late nineteenth century, developed into an expansive building covering two city blocks, where city dwellers could fill their baskets with fresh produce, such as the vegetables and fruits displayed here, carted in daily from area farms.

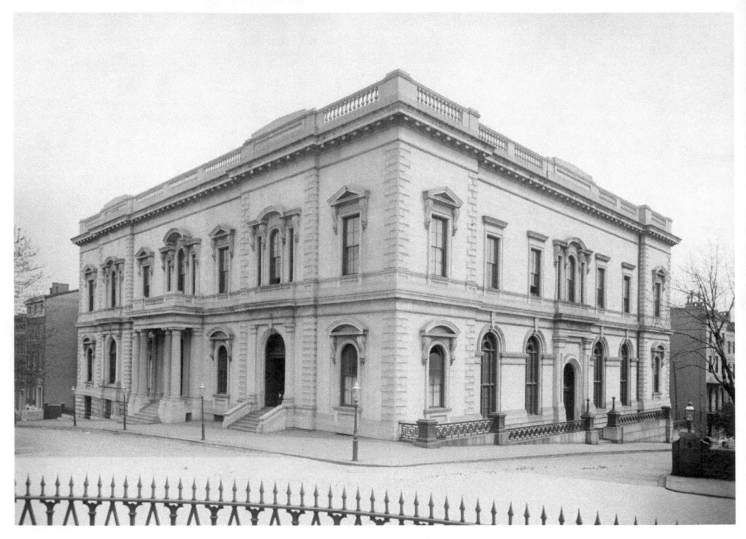

Massachusetts-born George Peabody accumulated a fortune as a merchant in mid-nineteenth-century Baltimore; he then gave thanks to the city with a $1.4 million gift to found a cultural institution of ambitious scope, to include a school of music, a library for scholars, an art gallery, and rooms for lectures and exhibitions. Designed by the architectural firm of Lind and Murdoch, the building on Mount Vernon Place known as the Peabody Institute was completed in 1861, but its dedication ceremony was postponed until after the Civil War.

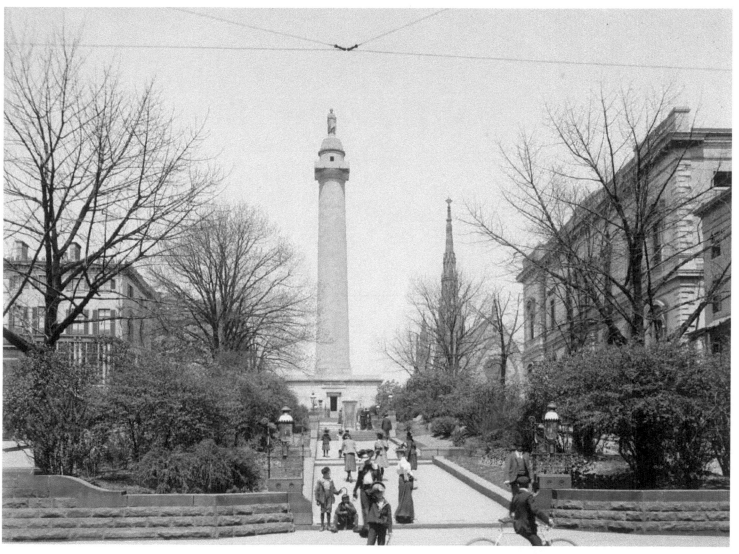

Baltimore's soaring Washington Monument, America's first public monument to George Washington, was designed by the noted South Carolina architect Robert Mills and begun in 1815. The monument's capital would be in position by 1820; still, seven years would pass before Enrico Causici, an Italian sculptor brought to America to work on the United States Capitol, would begin work on the 16-foot-tall representation of the commander in chief, standing boldly atop, dressed in a Roman toga, and captured in the act of resigning his military commission.

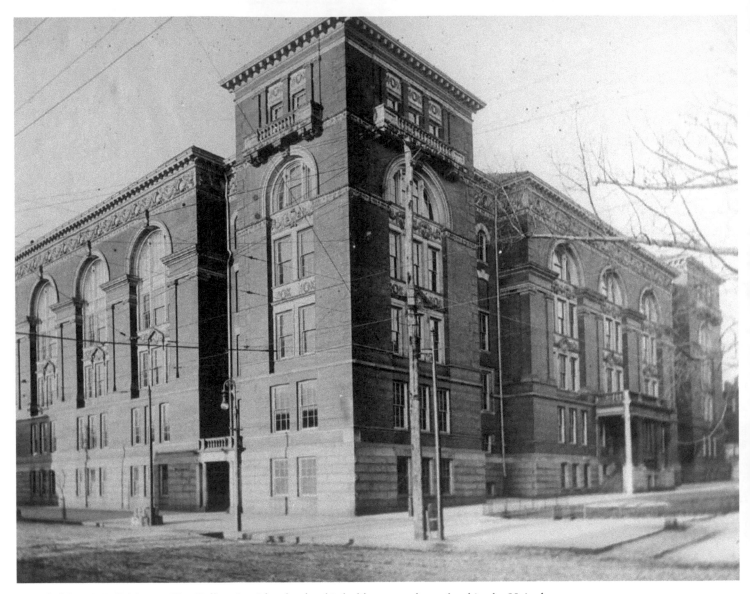

Founded in 1839, Baltimore City College is said to be the third-oldest secondary school in the United States. Located at Howard and Center streets beginning in 1875, the school moved into this building in 1899 after construction of the railroad tunnel under Howard Street undermined the previous building and caused its collapse.

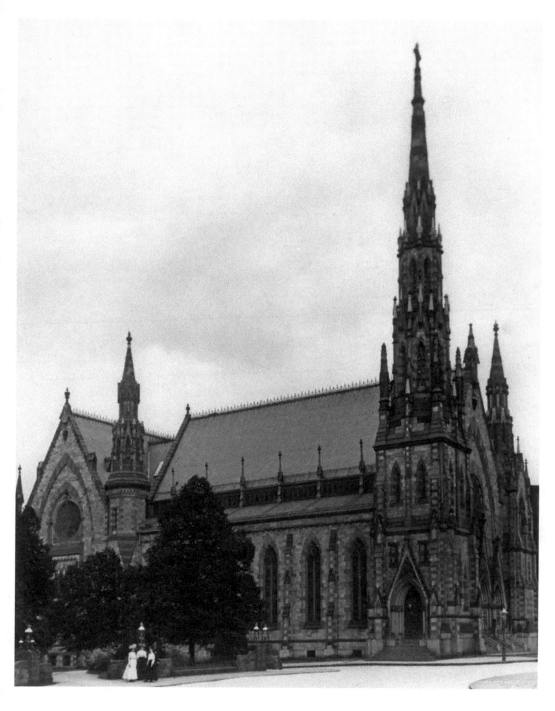

The most striking High Victorian Gothic church built in Baltimore was undoubtedly the First Methodist Episcopal church, located on Mount Vernon Square and seen here about 1900. Completed in 1872 and designed by architect-partners Thomas Dixon and Charles Carson, the church was intended to be a "Cathedral of Methodism."

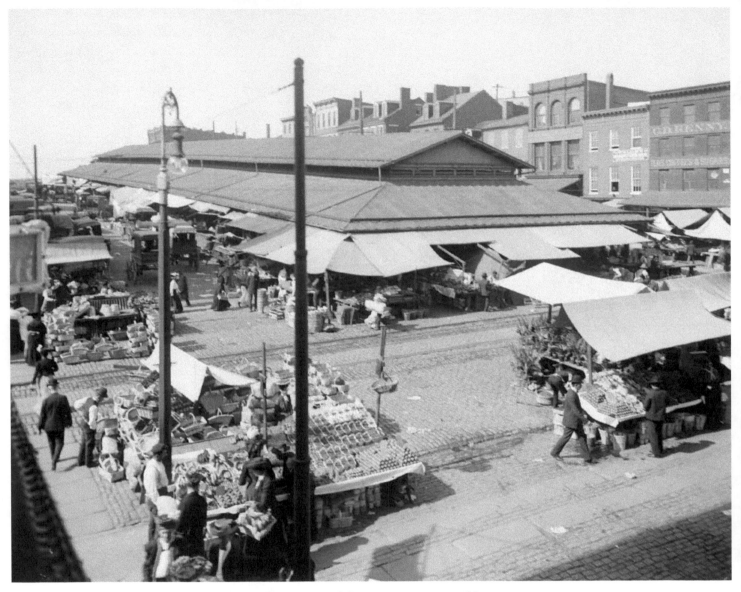

Lexington Market in 1900 remained a vital part of community life, attracting an array of farmers, butchers, importers, bakers, merchants, and craftsmen, all plying their wares. The market was originally opened only on Tuesday, Friday, and Saturday, from 2:00 a.m. to noon.

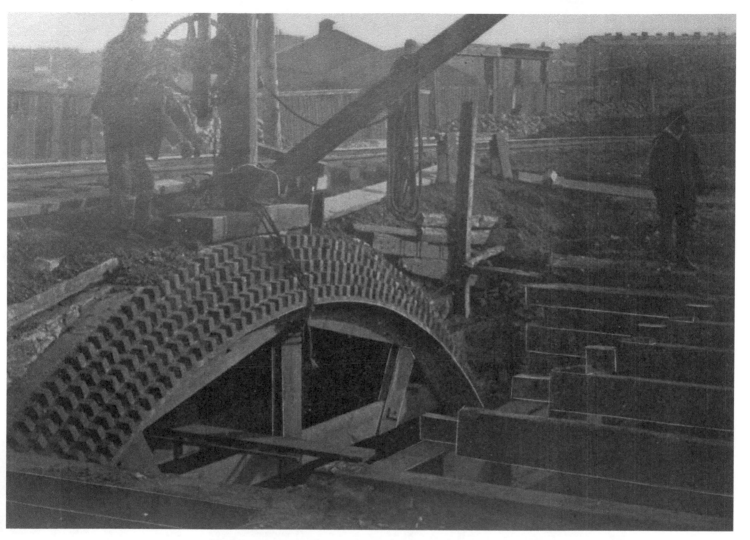

Under construction here in December 1901, the Boston Street Bridge, of brick arch design, replaced a metal girder bridge by which Boston Street had crossed over the Harris Creek sewer's outlet. A municipal project itself, the sewer was nearly 20 years old at the time the new bridge was built.

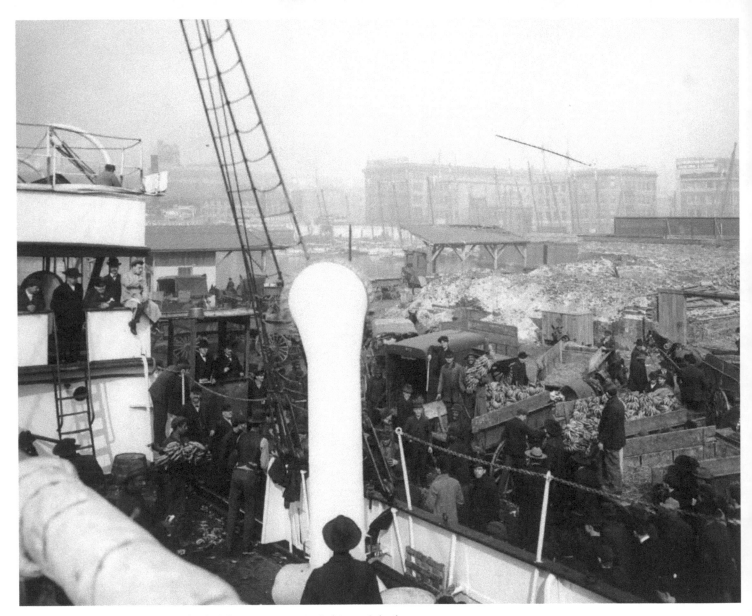

Fresh bunches of bananas are unloaded from a steamer in Baltimore's harbor.

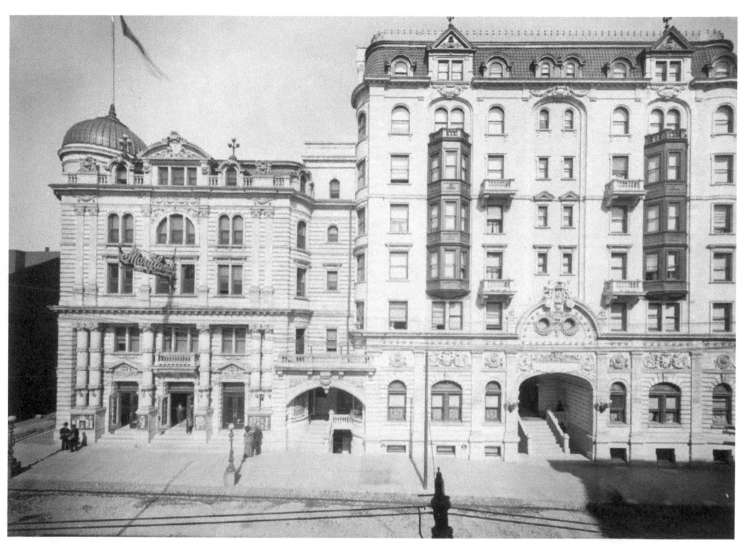

On the corner of West Franklin and Howard streets, entrepreneur James L. Kernan—a park commissioner and member of the city's jail board—built his Hotel Kernan and the adjacent Maryland Theater, opened in 1903. A popular music venue, the theater was home to the city's first jazz band, led by John Ridgely.

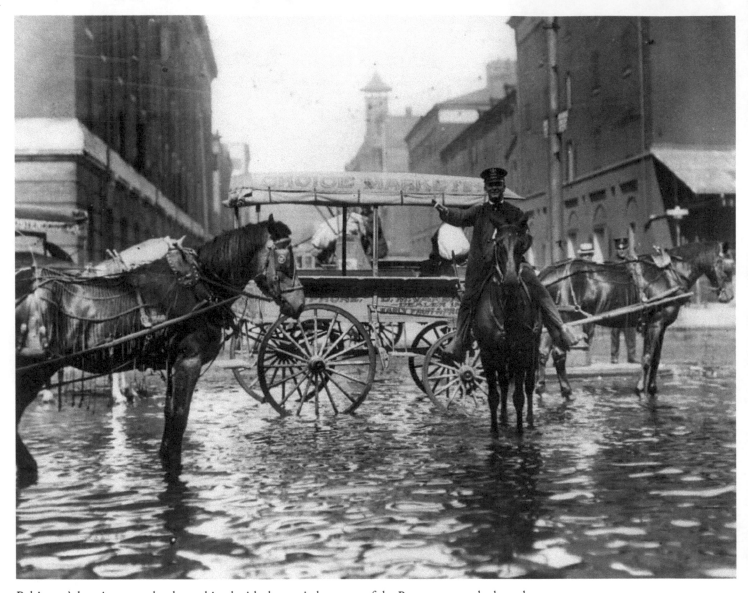

Baltimore's location at sea level, combined with the myriad streams of the Patapsco watershed, made the city prone to flooding, either from tidal surges or torrential downpours. Here at turn-of-the-century Light Street, near the city docks, a policeman guides carts and horses through the standing water.

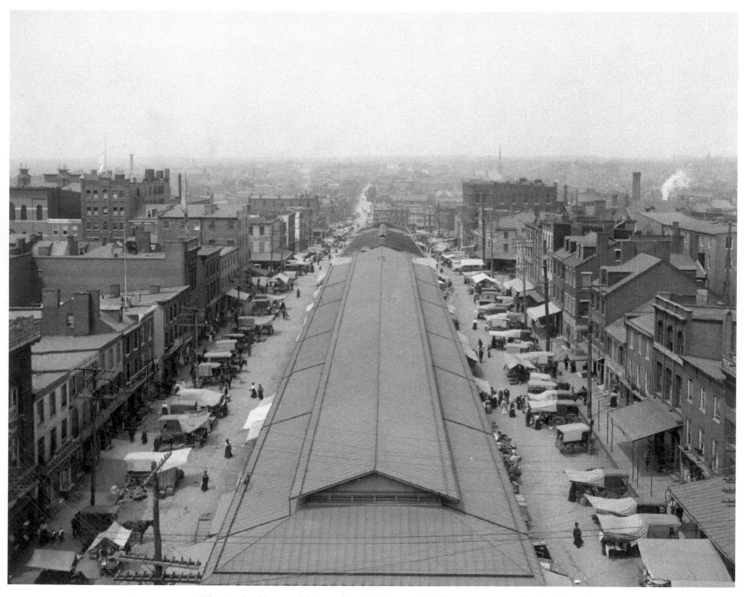

The city's oldest public market, Lexington Market, experienced a building boom in the post–Civil War years and by the turn of the century had grown into a sweeping, single-story structure of enormous length, surrounded by brick residential and commercial buildings.

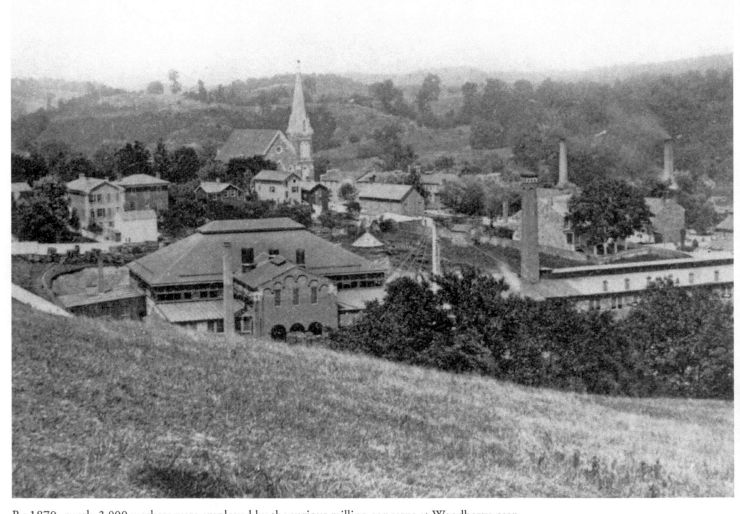

By 1870, nearly 3,000 workers were employed by the various milling concerns at Woodberry, seen here from Druid Hill Park. Entire families, including children, worked 12-hour days; in return, owners built housing, schools, churches, libraries, and savings and loan associations for their workers.

Mount Royal Station, designed by the Baltimore architectural duo of E. Francis Baldwin and Josias Pennington and opened in 1896, served the nation's first electric locomotive main line, established by the B&O in 1895 and known as the Baltimore Belt Railroad. The line was electrified to resolve safety issues created by smoke that billowed out of the steam locomotives as they passed through the 1.25-mile-long tunnel situated under a residential section on Howard Street—the smoke not only obscuring tunnel signals but considered a serious health hazard to neighbors. Rising in the background is the station's 150-foot clock tower, its heavy granite walls belying the rich ornamentation of the station's interior.

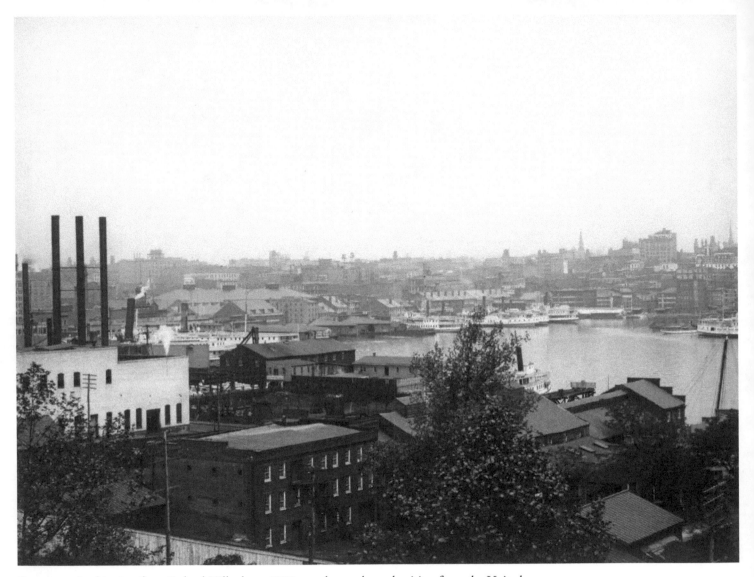

Prominent in this view from Federal Hill, about 1903, are the smokestacks rising from the United Railways and Electric Company power generating plant begun in 1895 and located at Pier 4. The plant held huge coal-fired engines that produced the electricity for the city's streetcar system.

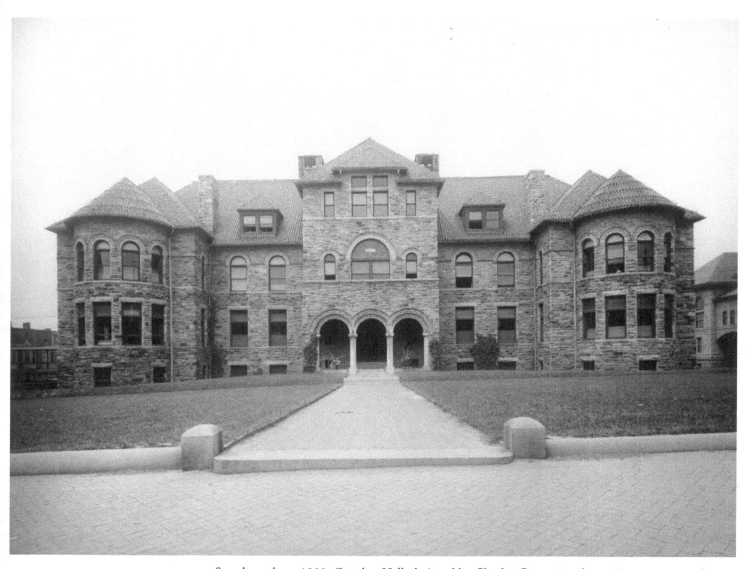

Seen here about 1903, Goucher Hall, designed by Charles Carson in a heavy Romanesque style, was constructed in 1887 as the central building for the Women's College of Baltimore, the Methodist school begun two years earlier by ministers Dr. John Goucher and John B. Van Meter. In 1910, the school was renamed Goucher College in honor of its founder.

The Great Fire broke out Sunday morning, February 7, 1904, at Hurst and Company's dry goods store at the corner of Liberty and German (now Redwood) streets. Seen here is the Hurst building just 15 minutes after the first alarm.

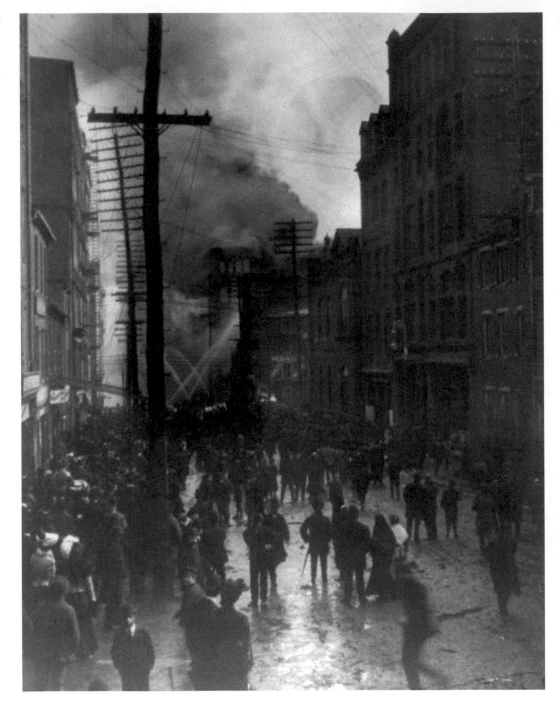

Disaster Converted

(1904–1939)

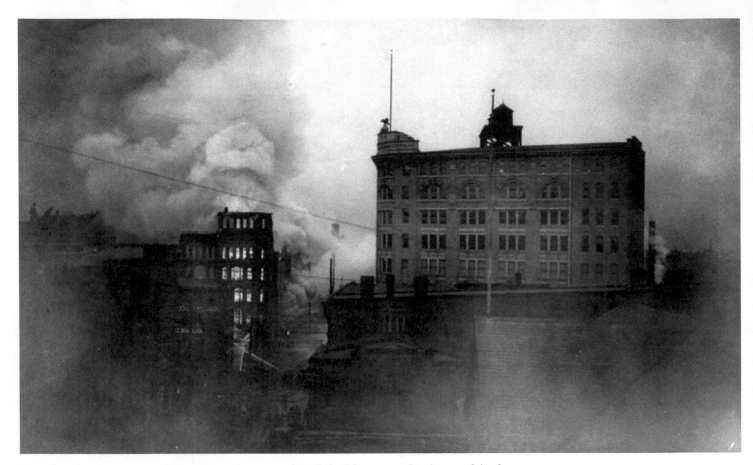

Here flames prepare to engulf the Guggenheimer and Wells building as, within hours of the first alarm, the city's business district becomes an inferno. By Sunday afternoon the flames were climbing the sides of the supposedly fireproof skyscrapers along Fayette Street, shooting sparks hundreds of feet into the air, igniting surrounding structures. The Sun newspaper's venerable iron building, believed to be imperishable, was completely destroyed in the 1904 fire.

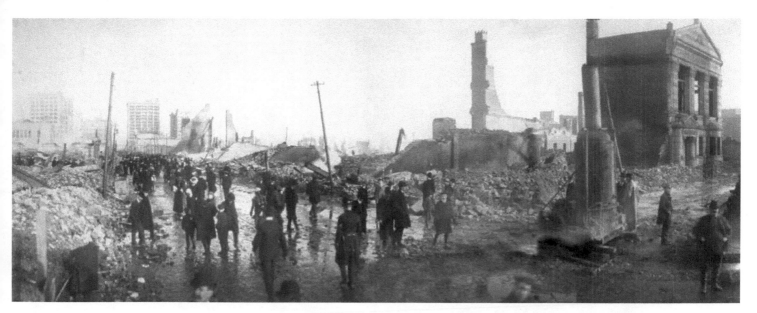

All through the night and into Monday morning, the blaze burned on, the flames leaping from building to building, west of Jones Falls and then, with a shift in the wind, south to the waterfront. Only the facade of the Hopkins Place Savings Bank remained standing.

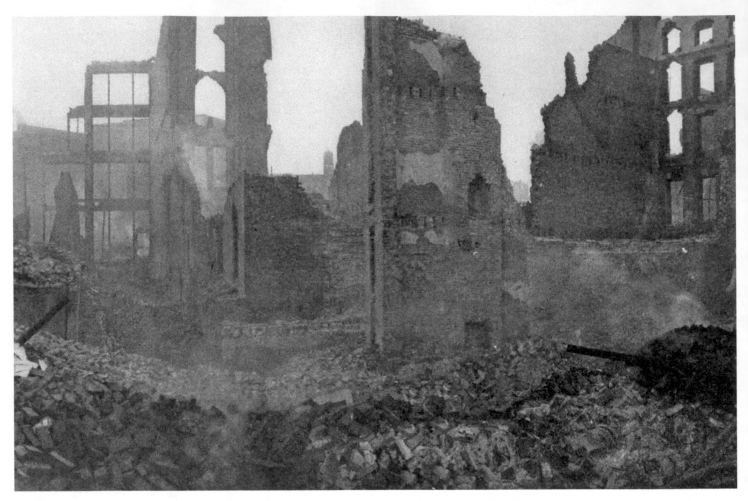

The wholesale-goods district around German and Hanover streets, where the fire began, collapsed into burnt rubble.

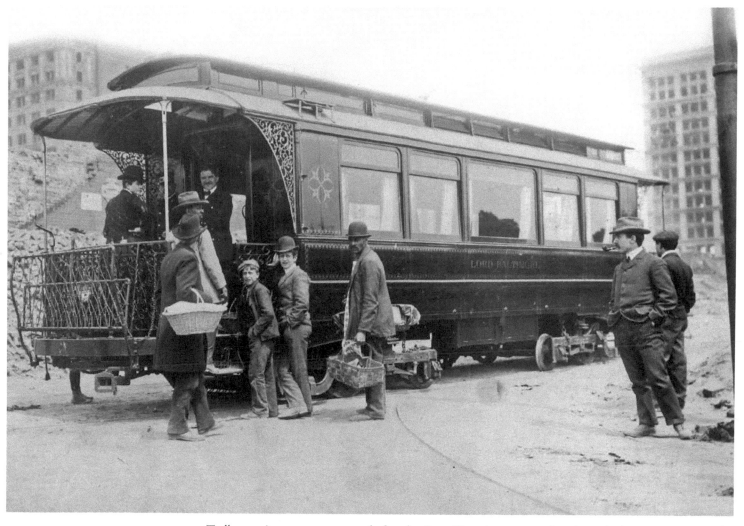

Trolley service was soon restored after the Great Fire, the cars running through the eerie remains. The quick restoration of the streetcars, like the *Lord Baltimore* seen here, did much to bind the city back together and get it working once more.

Designed by the famed Chicago architect Daniel H. Burnham in 1899 and completed in 1901, the Continental Trust Building, at the vcorner of Baltimore and Calvert streets, briefly stood as the tallest building south of New York. The building's steel-cage framework saved it from total destruction in the Great Fire of 1904; still, the severely damaged building was essentially reconstructed through the following year and is seen here about 1906. Dashiell Hammett, the celebrated author of crime fiction, worked in the building from 1915 to 1918 as an operative for the Baltimore branch of Pinkerton's National Detective Agency.

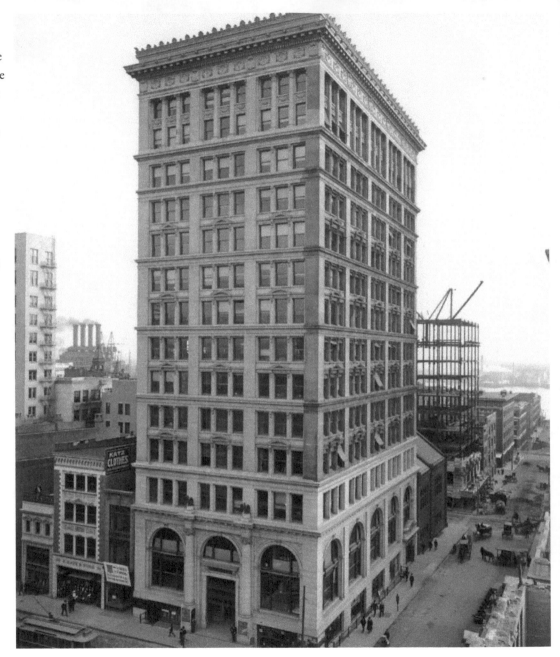

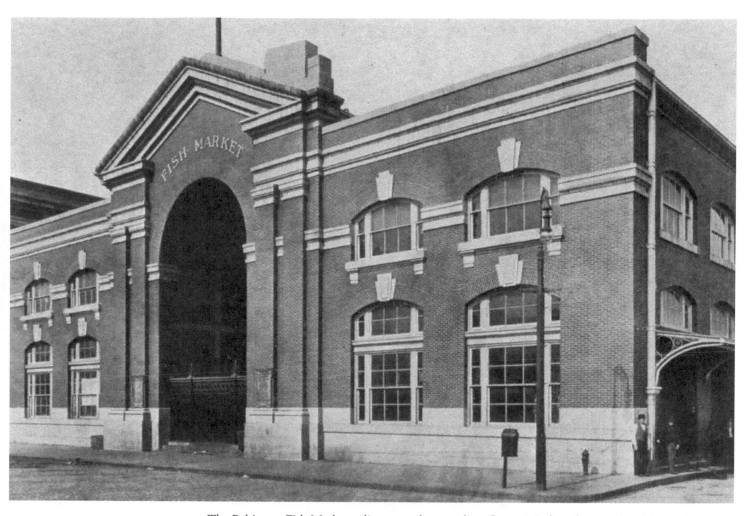

The Baltimore Fish Market, adjacent to the sprawling Center Market, dates to the eighteenth century and operated as the city's official wholesale seafood marketplace. The impressive brick building seen here was built after 1904, when the original structure was destroyed in the Great Fire.

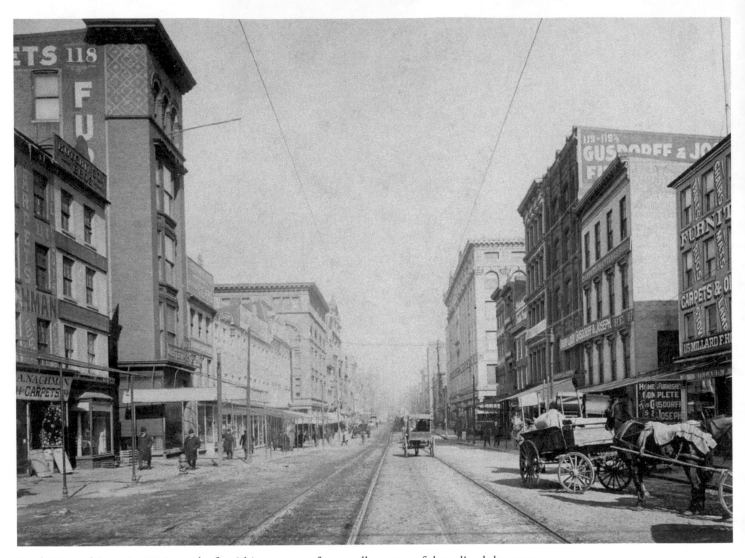

North Howard Street in 1905 was the furnishings center of town; all manner of shops lined the streets, touting an endless array of items prime for interior design, from floor coverings to the latest styles of furniture.

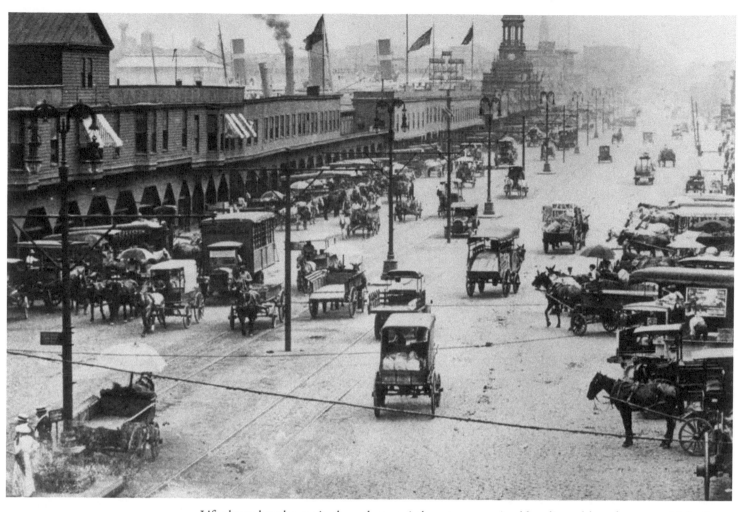

Life along the wharves in the early twentieth century remained bustling, although now on Light Street horse-drawn wagons intermingled with gasoline-driven trucks, vans, and Model T Fords, all carrying goods and passengers to and from the harbor.

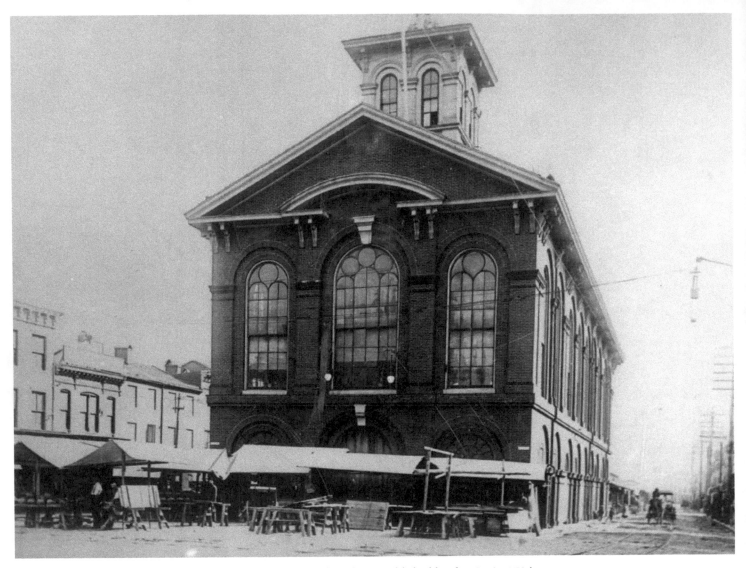

Broadway Market in Fell's Point was one of the three original markets established by the city in 1784 and, although smaller than either Lexington or Center Market, did a trade brisk enough to warrant the construction of a handsome, brick market building, erected in 1864.

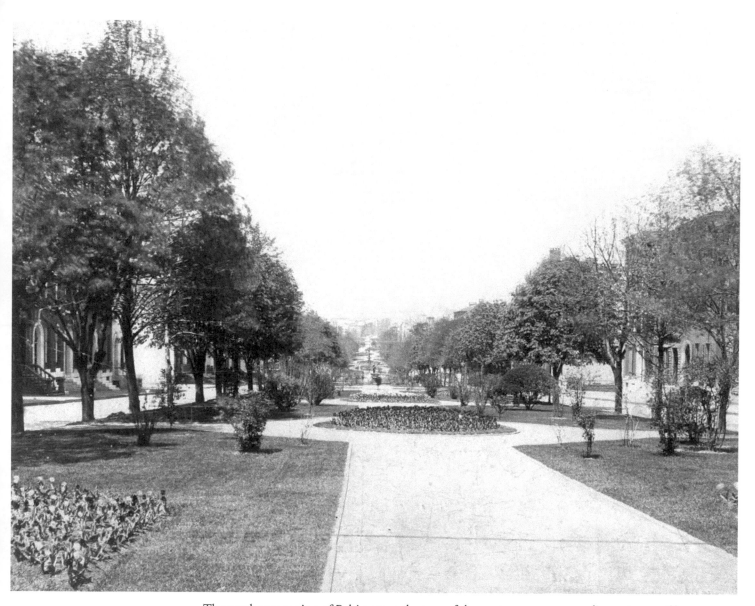

The northwest section of Baltimore at the turn of the century was an appealing mixture of large estates and manicured streets lined with stylish row houses. A major enticement for home seekers was Eutaw Place, which extended from Dolphin Street northward and was a gift from Henry Tiffany to the city in 1853. Seen here about 1905, the wide, ornately landscaped strip of greenery ran for nine blocks.

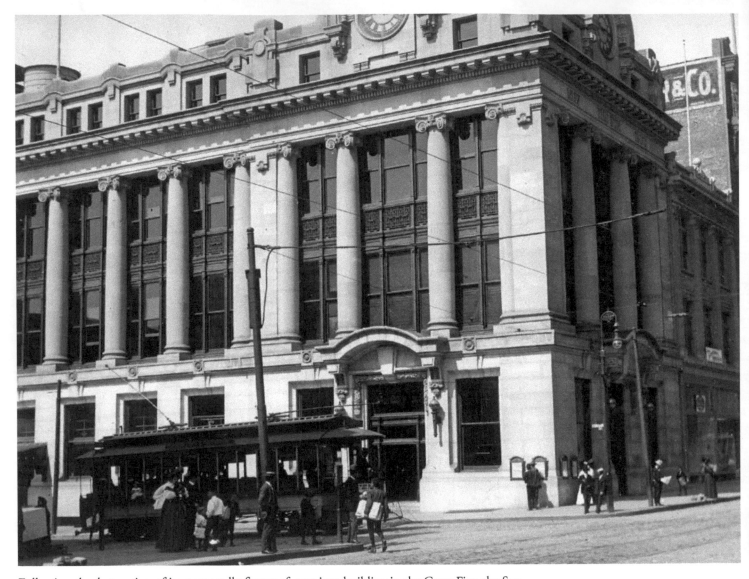

Following the destruction of its supposedly fireproof, cast-iron building in the Great Fire, the Sun newspaper began construction of a new headquarters, seen here, on the corner of Baltimore and Charles streets. The massive, classically inspired Sun Building opened for business in November 1906. That same year, a young editor by the name of H. L. Mencken joined the staff to manage the newly created Sunday edition. The celebrated author and American journalist would remain actively associated with the Sunpapers until a stroke suffered in 1948 forced his retirement.

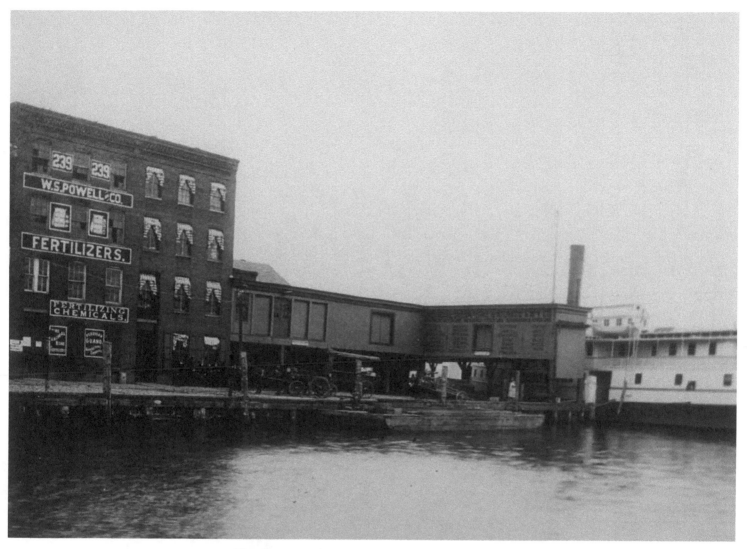

The discovery of the fertilizer guano—bird and bat droppings rich in phosphate and nitrogen—provided area farmers with a powerful means of reviving lands worn by centuries of cultivation. By the mid nineteenth century, Baltimore had become the nation's numberone importer of the natural fertilizer, and by the 1880s, fertilizers would become the second most economically important endeavor in the city, just behind men's clothing. At Bowley's Wharf, off Light Street—one of the first wharves established on the inner harbor—the warehouses of W. S. Powell, seen here in 1904, were filled with all manner of fertilizers and chemicals, including Peruvian guano.

The remnants of a winter's snow dot the sidewalks and perimeter of Howard Street around 1910, as a crush of trolleys carry passengers around the city and out to the steadily growing suburbs.

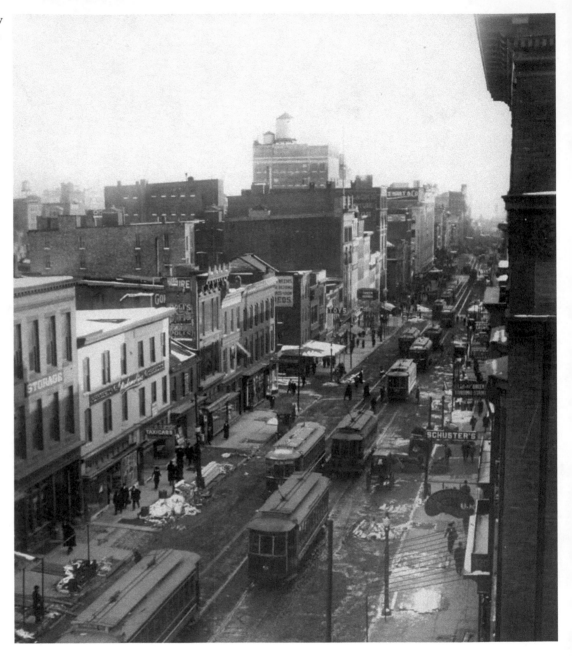

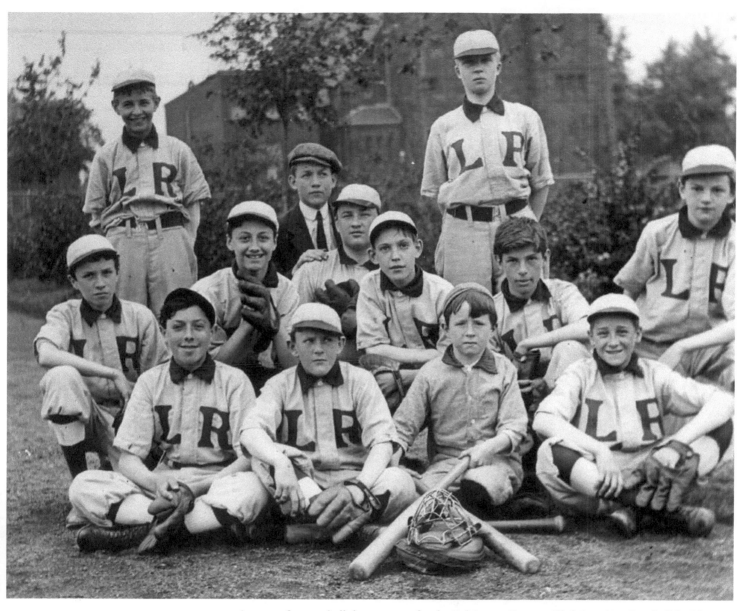

A team of young ballplayers poses for the Baltimore Camera Club in 1908. Baseball had been a city passion since June 4, 1860, when the Baltimore Excelsior Base Ball Club beat the Washington Potomacs in a game played on the Ellipse behind the White House in Washington, D.C. In a fantastically high scoring game, the Baltimore club won, 40–24.

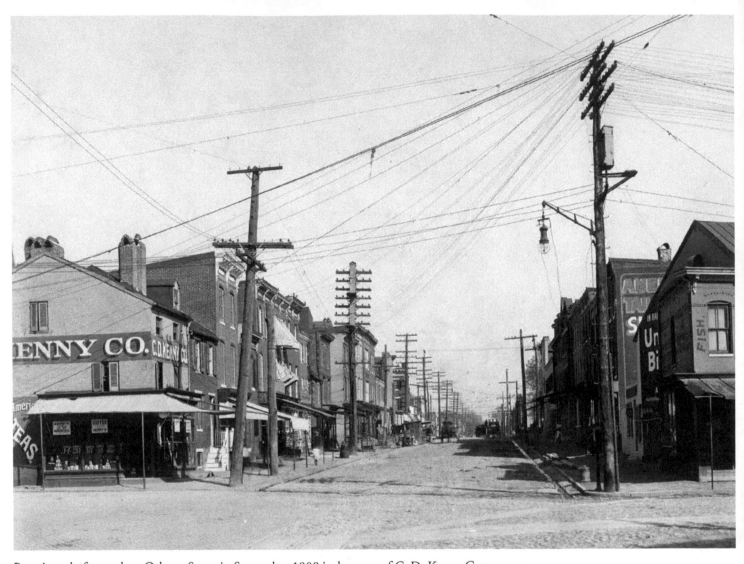

Prominently featured on Orleans Street in September 1908 is the store of C. D. Kenny Company, a local importer of teas, coffee, and sugar originally established in 1870. In 1939, Nathan Cummings borrowed $5.2 million to buy the Baltimore-based company and immediately began to increase the number of Kenny-label products. The corporation continued to grow through acquisition and in 1985 consolidated all its companies under one name, the Sara Lee Corporation.

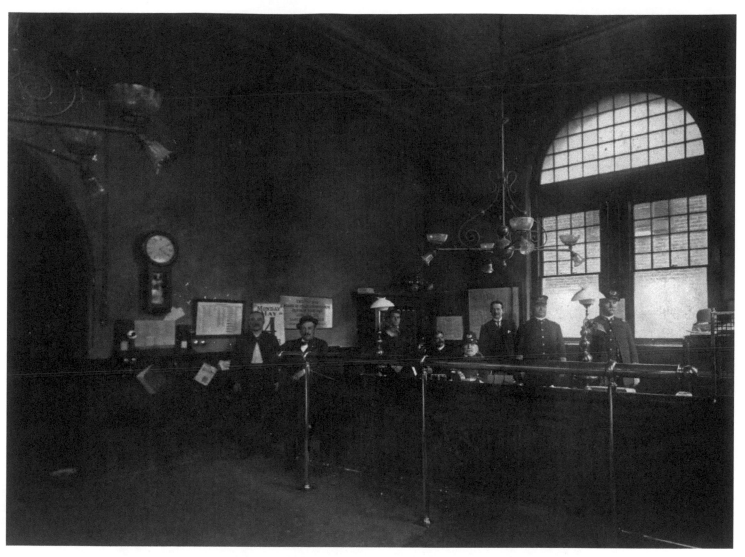

Baltimore had been developing a police force since the formation in 1784 of a night watch "very necessary to prevent fires, burglaries, and other outrages and disorders." By the time of this May 1908 photograph, the force was governed by a state board, appointed by the governor of Maryland.

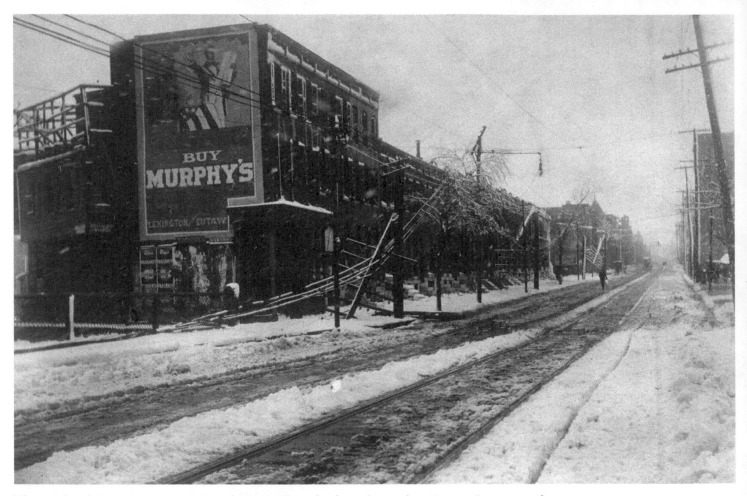

The weight of a late winter storm in March 1909 collapsed poles and trees along Preston Street west of Jones Falls.

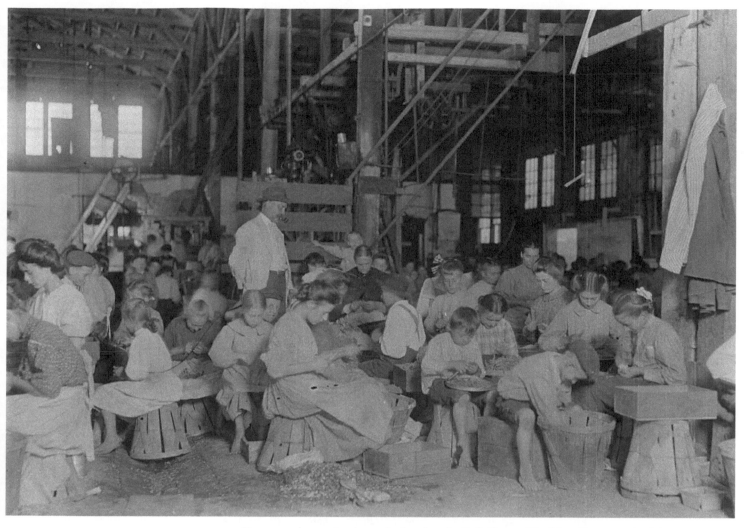

Young workers string beans by hand at the J. S. Farrand Packing Company in this 1909 image recorded by photographer Lewis Hine. Those with babies in tow held them on their laps while working or else "stowed" the babies in empty boxes, the National Child Labor Committee record indicated.

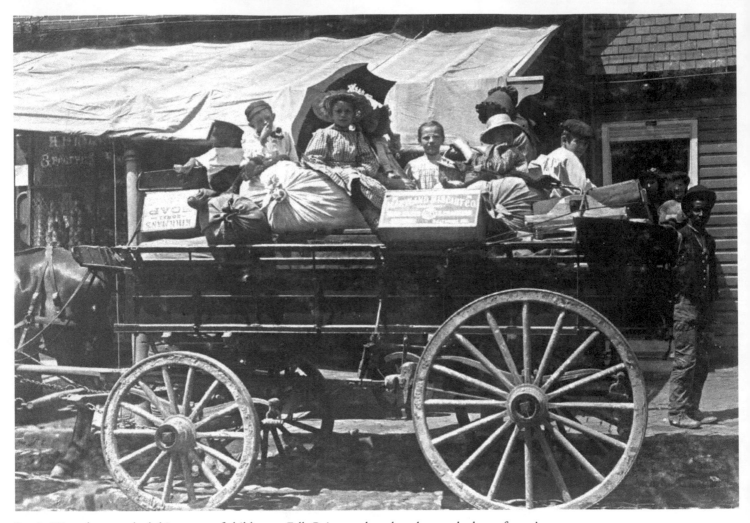

Lewis Hine photographed this wagon of children at Fells Point, ready to be taken to the berry farms in the surrounding Maryland countryside.

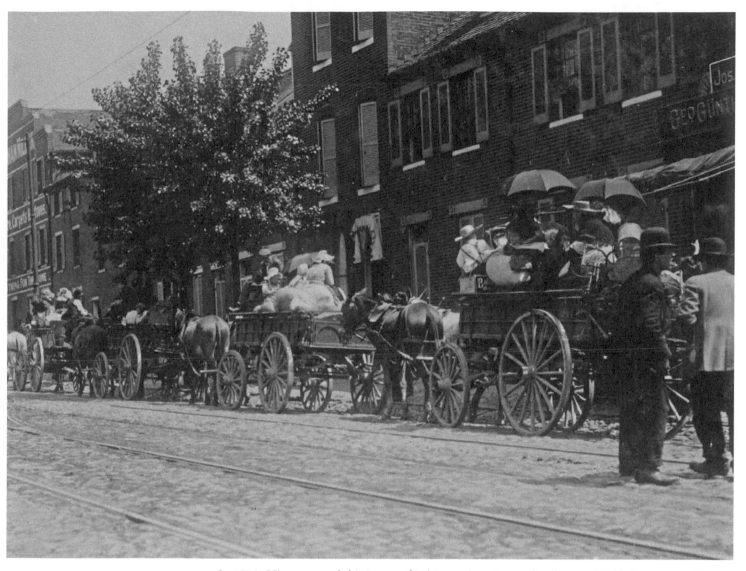

In 1910, Hine captured this image of Baltimore immigrants lined up on Wolfe Street, near Canton Avenue, ready to start for the country to harvest produce on area farms.

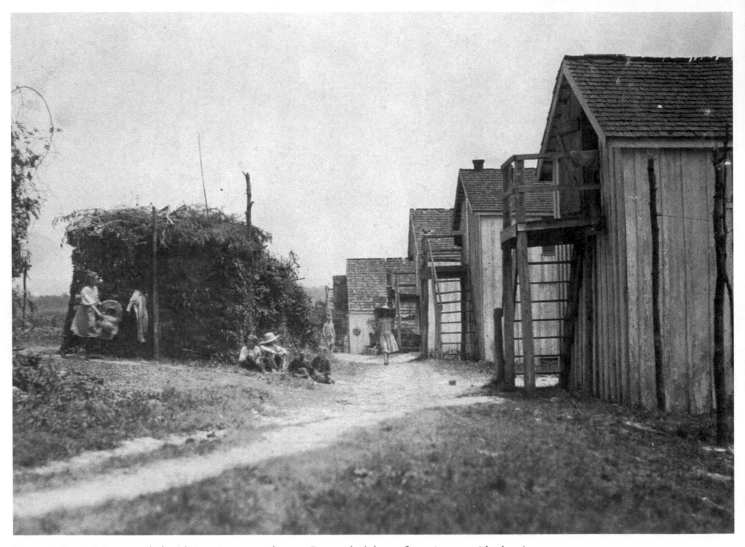

In 1909, Lewis Hine traveled with immigrant workers to Bottomley's berry farm, just outside the city limits, and took this photograph displaying the working and living conditions. The cabins on the right housed as many as four families in each two-room shanty.

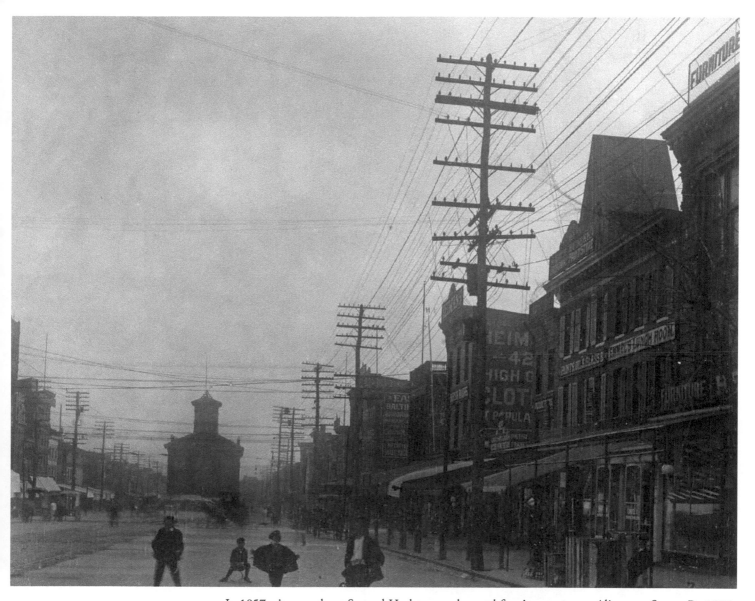

In 1857, city merchant Samuel Hecht opened a used furniture store on Aliceanna Street. By 1870, his venture had grown so successful that he moved to a more auspicious location on South Broadway, shown here in 1911. His name was carved in foot-tall letters on the granite lintel over the doorway. By 1879 he had added clothing to his offerings, under the name "Hecht's Reliable." He opened a carpet and matting store on West Lexington Street shortly thereafter.

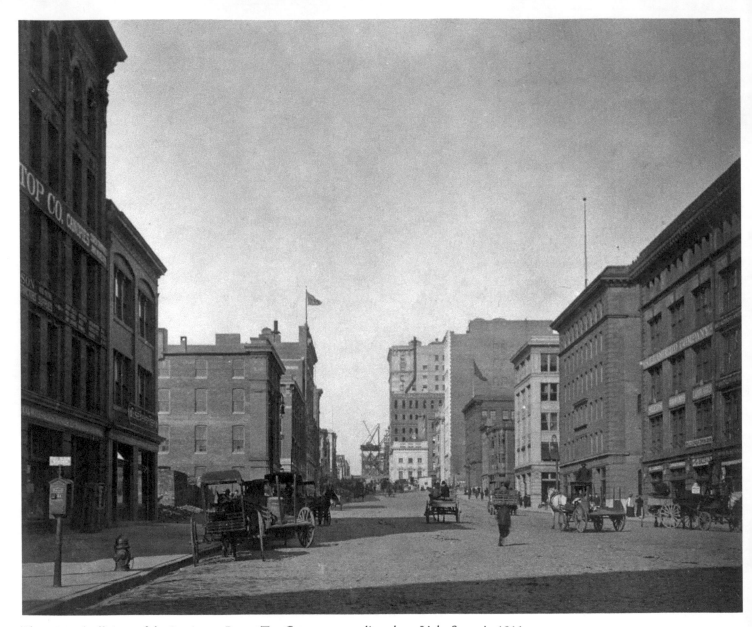

The original offerings of the Larrimore Buggy Top Company, standing along Light Street in 1911, would soon go the way of the horse and carriage as the automobile age entered full swing in the first decades of the twentieth century.

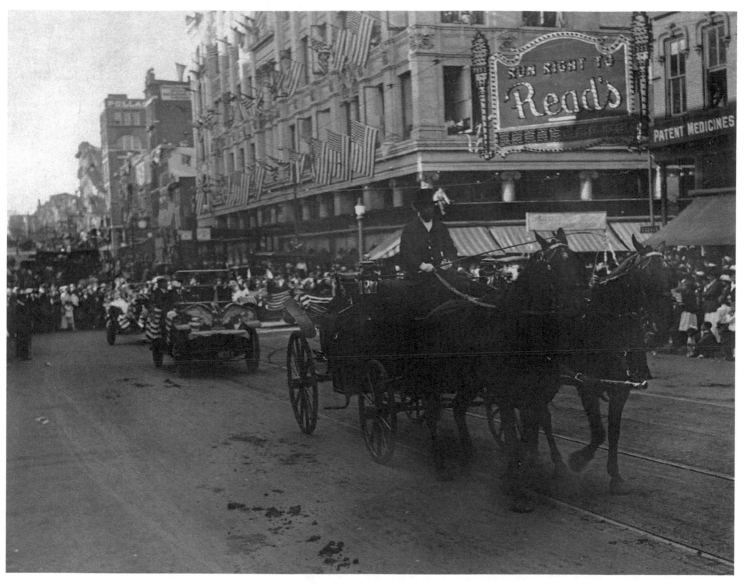

A patriotic parade passes by Read's Drug Store in 1911. The popular chain of pharmacies located throughout the area in the twentieth century—with its familiar slogan, "Run Right to Read's"—was eventually bought by the Rite Aid Corporation as part of its 420-store acquisition campaign along the East Coast in the early 1980s.

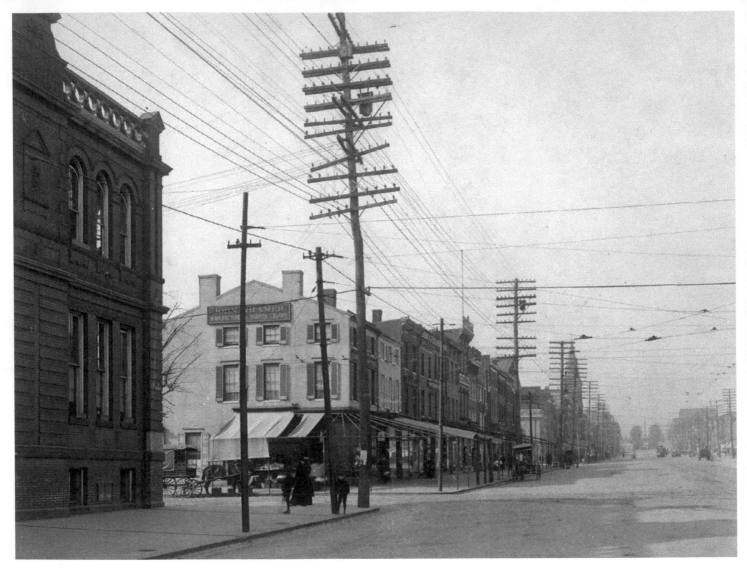

South Broadway indeed lives up to its name in this 1911 view near the intersection with Gough Street.

The Broadway Market in Fell's Point is a visible and familiar landmark in this 1911 view looking down South Broadway to the harbor.

The gas lanterns lining Howard Street in 1912 are reminders of Baltimore's role in bringing gas lighting to America. In 1816, Rembrandt Peale first demonstrated gas lighting at his museum in town, and it proved such a sensation and success that Peale organized a gas company to light the city— making Baltimore the first city in the country with gas streetlights.

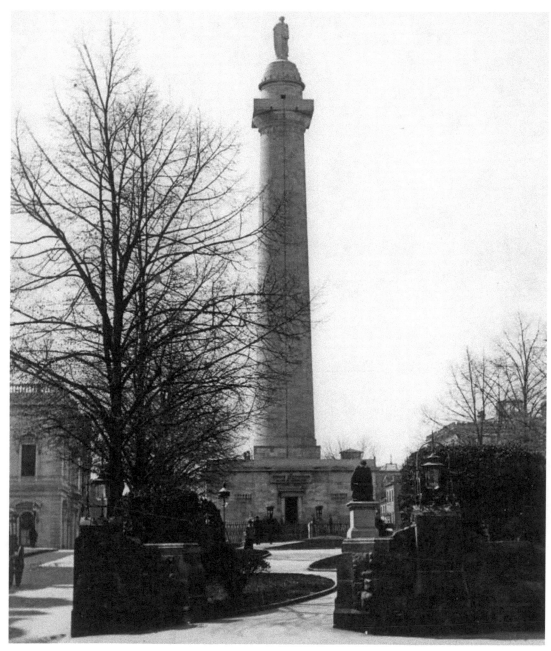

Through the last half of the nineteenth century, Mount Vernon Place's parks were periodically relandscaped to keep with the fashion of the day. Trees were allowed to grow, then cut down because they blocked the view. In the east and north squares, the city erected statues to the memories of noteworthy residents George Peabody, the merchant and philanthropist; Severn Teackle Wallis, an early political reformer; Roger Brooke Taney, chief justice of the United States Supreme Court; and John Eager Howard, Revolutionary War hero. This view shows Mount Vernon Place in 1912.

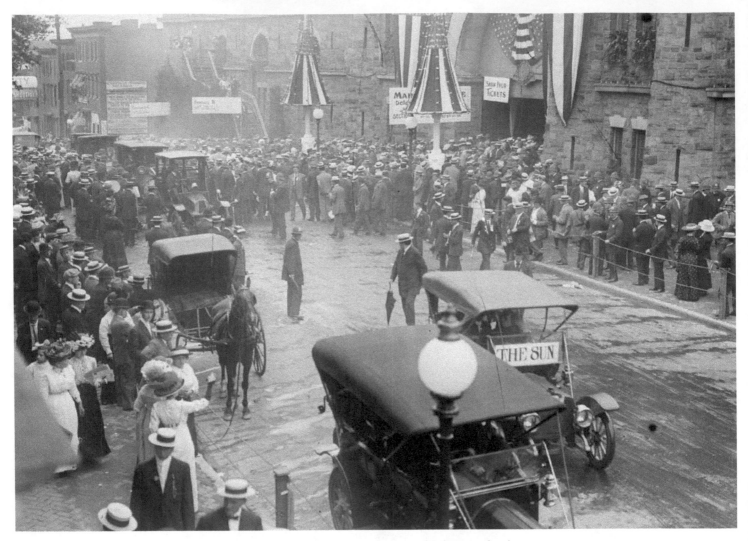

As seen here, Democrats from across America gathered in Baltimore in June and July 1912 for the party's national nominating convention. The city's advantageous geographic location and accessibility by rail, road, and water made Baltimore a desirable meeting place. More than 80 years earlier, in Baltimore in 1831, a splinter party called the Anti-Masons held the nation's first such convention, setting an example followed the next year by the Jackson Democrats—a Baltimore event distinguished as America's first major-party nominating convention.

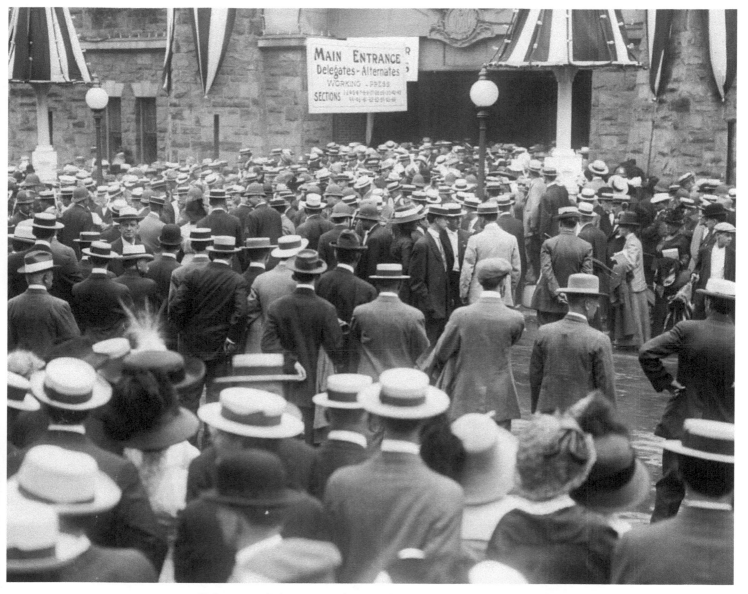

Delegates and alternates at the 1912 Democratic Convention in Baltimore crowd the front of the Fifth Regiment Armory, anxious to enter the hall.

Here in 1914, East Lombard Street retained much of its early nineteenth-century charm.

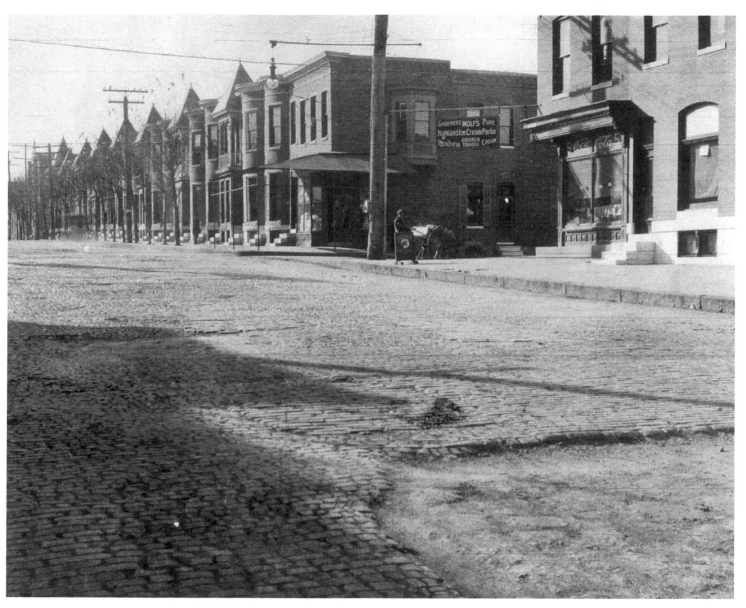

Against the advice of state roads engineers, brick pavement was laid on a gravel base on this city street, creating by 1915 rutted, crumbling surfaces that jarred passing automobiles.

Despite the growing availability of motorized transportation in 1915, the city roads maintenance crews still relied on the horse and cart.

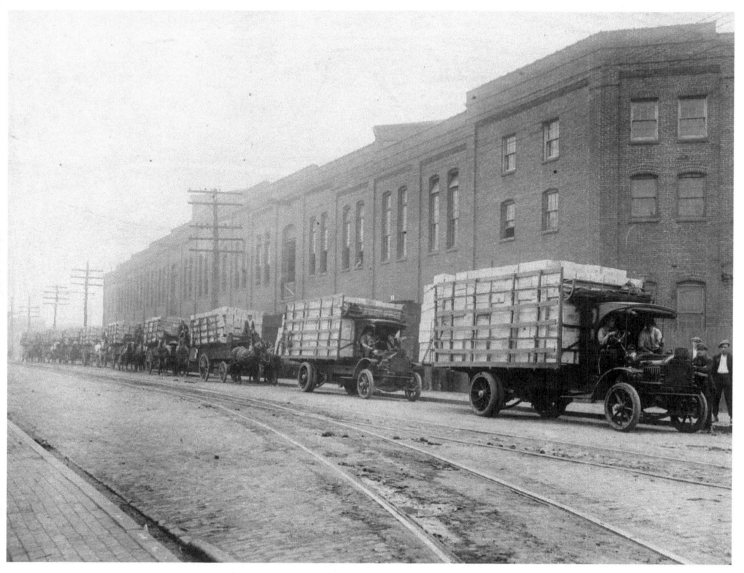

Loaded trucks line the curb outside the Baltimore warehouse of the American Can Company around the time of World War I. Originally a property of the Norton Tin Plate and Can Company, the Baltimore facility was eventually absorbed by the American Can Company, which by 1908 had grown to be the largest can manufacturer in the world.

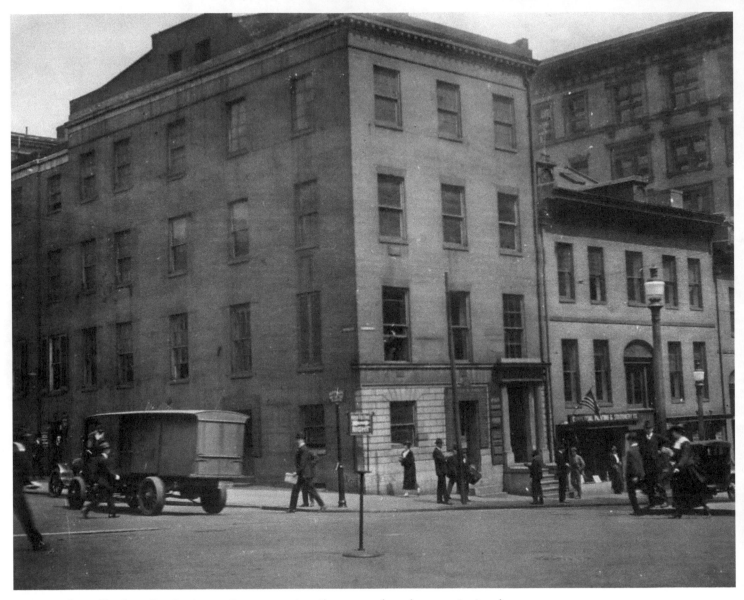

By 1918, the traffic along East Lexington Street was primarily autos and trucks, necessitating the emergence of new traffic signs such as this one reminding vehicles to keep to the right.

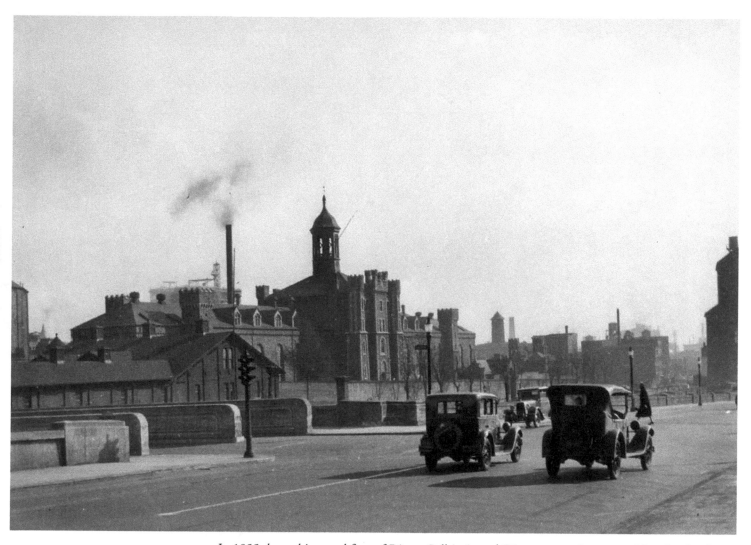

In 1855 the architectural firm of Dixon, Balbirnie and Dixon won a city competition for the design of a new jail. The firm received $500 as its prize. Completed in 1859, the jail contained 300 cells in each of two wings that extended from a main administrative block distinguished by a somber gray stone exterior and crenellated towers, which one contemporary Baltimore paper stated was "decidedly appropriate."

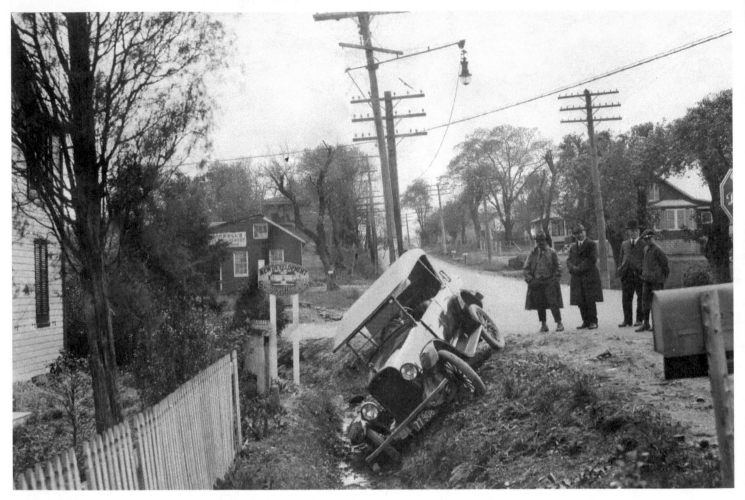

An automobile accident on the outskirts of Baltimore in the 1920s is a persuasive argument for guardrails.

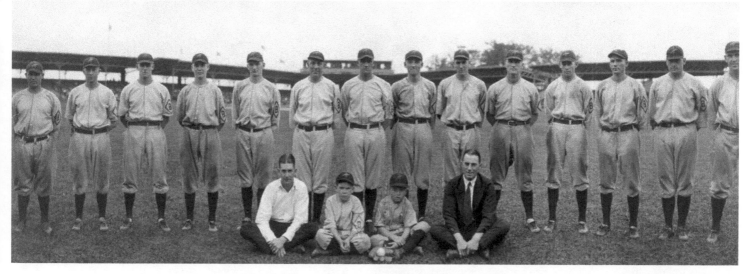

After fielding several amateur and professional teams in the early days of baseball, the Baltimore Orioles joined the International League in 1903 and by 1919 had captured the pennant as the first 100-win champion in league history. Baltimore followed in 1920 with a 110-victory pennant-winning season. The 1921 team, seen here, shattered all International League records, finishing the season 119-47 while setting records for runs, hits, doubles, home runs, total bases, batting average, and attendance, drawing 308,970 fans.

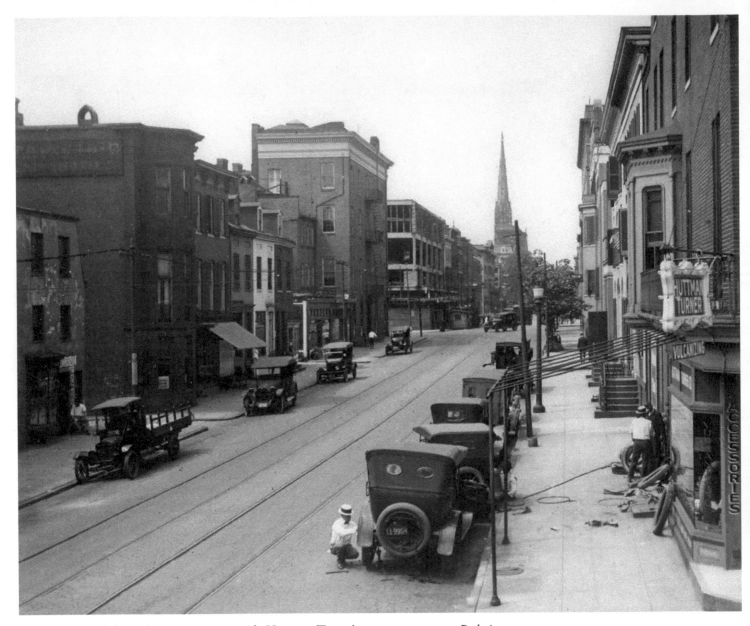

A car gets a needed tire change in 1923 outside Huttman Turner's auto parts store on Park Avenue.

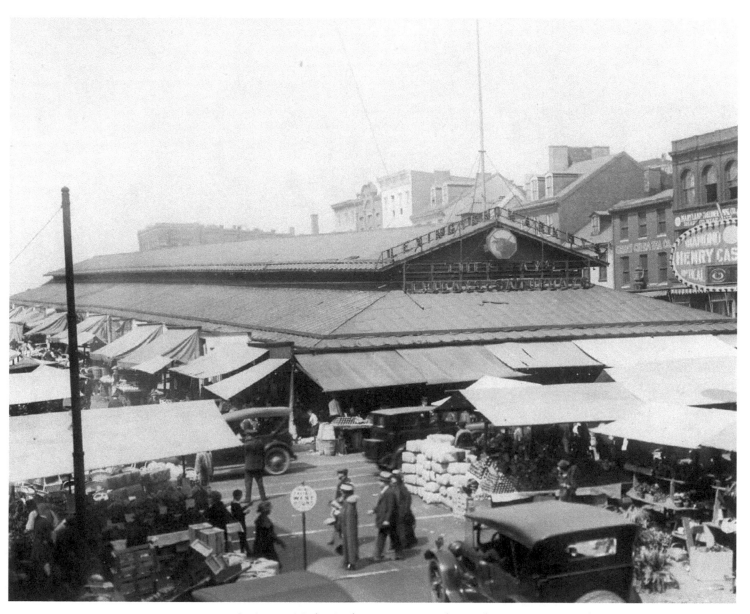

Lexington Market in the 1920s remained as vital as ever, attracting farmers and merchants from all over the region and fostering the growth of a dizzying collection of commercial establishments hawking everything from diamonds to spectacles.

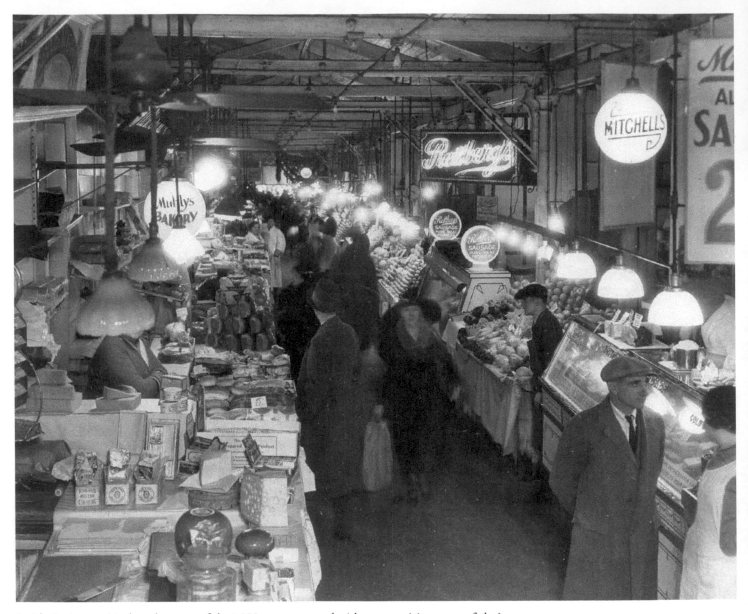

Inside Lexington Market, shoppers of the 1920s are presented with an appetizing array of choices.

Known as that "elegant Rendezvous for taste, curiosity and leisure," Peale's Baltimore Museum and Gallery of Fine Arts on Holliday Street was opened in 1814 by Rembrandt Peale—the classically named offspring of master painter Charles Wilson Peale. The gallery exhibited an eclectic mix of fine paintings and natural oddities, such as woolly mammoth bones exhumed by father Charles, all housed in what was the world's first building constructed specifically as a museum. Later falling into disrepair, as seen here, the building would be restored in 1931.

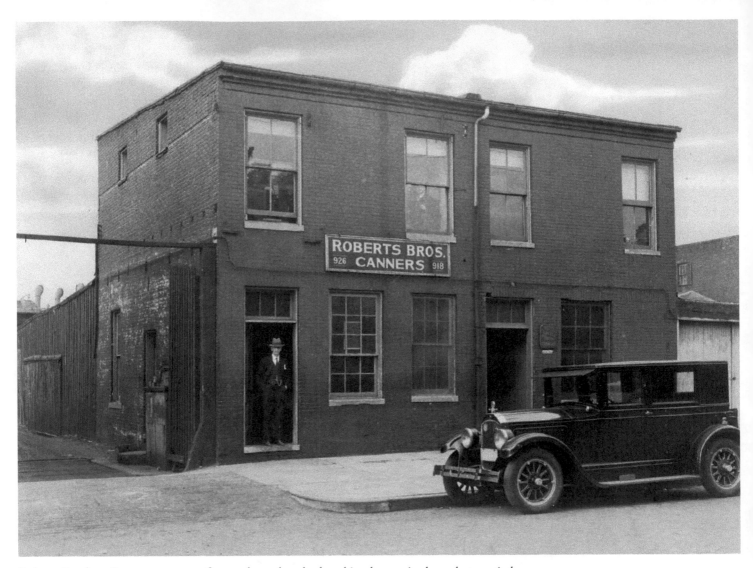

Roberts Brothers Canners was one of more than a hundred packing houses in the early twentieth century that employed men, women, and children to not only process the food that went into the cans, but also the labels that went on them and the boxes they were shipped in. By the 1940s, Baltimore made more cans than any other city in America.

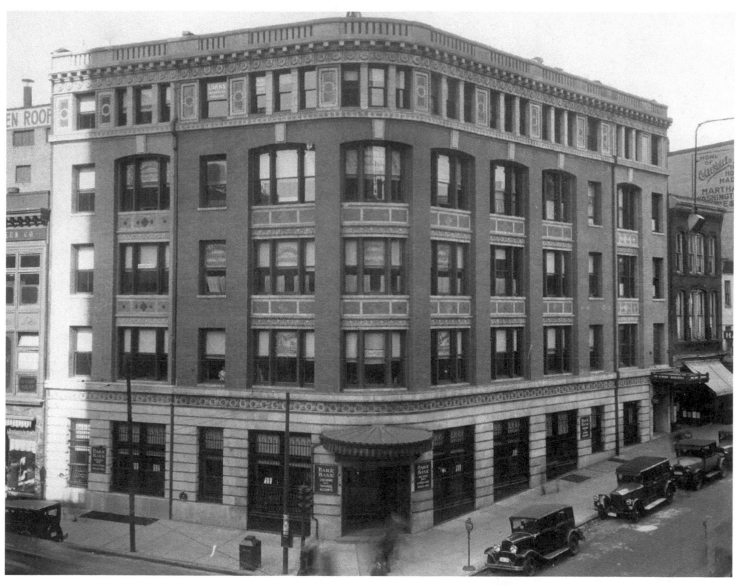

Seen here near the close of the 1920s, the Park Bank building rounded the corner of Lexington and Liberty streets. By 1931, the Great Depression had hit the Baltimore banking industry hard—even the venerable Baltimore Trust Company shut the doors to its 32-story skyscraper. By 1933, the governor of Maryland had closed all banks in an effort to prevent mass withdrawals.

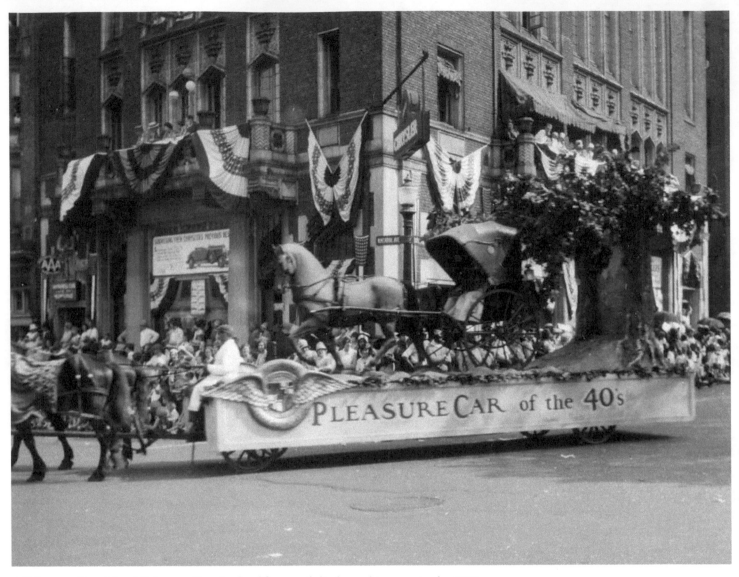

A "Pleasure Car of the 40's," one of hundreds of floats and displays taking part in the 1929 bicentennial celebration of the founding of Baltimore, passes by a Chrysler dealership. A parade of more than 400 cars was a highlight of the ceremonies.

At the corner of Lexington and Liberty streets in 1929, the Consolidated Gas Electric Light and Power Company—which became the Baltimore Gas and Electric Company—presents a dazzling display of the power of electric lighting, majestically illuminating its headquarters building designed by the architectural firm of Parker, Thomas and Rice and completed in 1916.

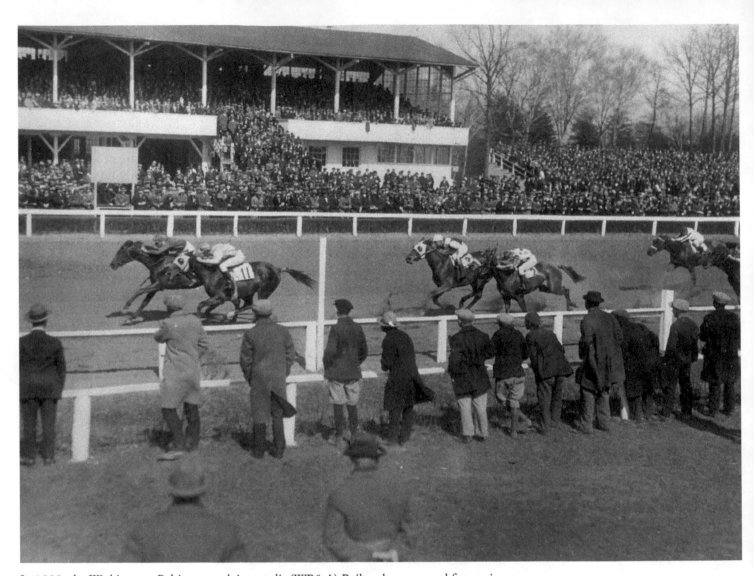

In 1908, the Washington, Baltimore and Annapolis (WB&A) Railroad was opened for service, running from Liberty Street in Baltimore to a terminal at the corner of 15th and H streets in Washington, D.C. A direct competitor of the B&O, the WB&A sought to build ridership by establishing attractions along the route. In 1914, the company convinced the Southern Maryland Agricultural Society to build the Bowie Race Track, seen here in 1930. The track was located near the home of the Belair Stud Farm, founded by Samuel Ogle in 1747 and known as the "cradle of American thoroughbred racing."

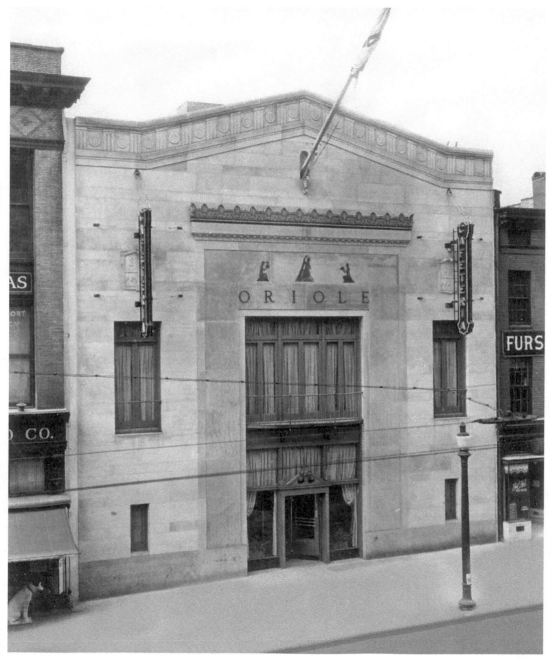

Seen here in 1930 at one of four locations, the Oriole Cafeteria sought to wed the speed and convenience of cafeteria self-service with the dining comforts of a traditional restaurant. In the storefront window next door, at left, a replica of the RCA Victor trademark dog Nipper appears to be pining for Oriole scraps.

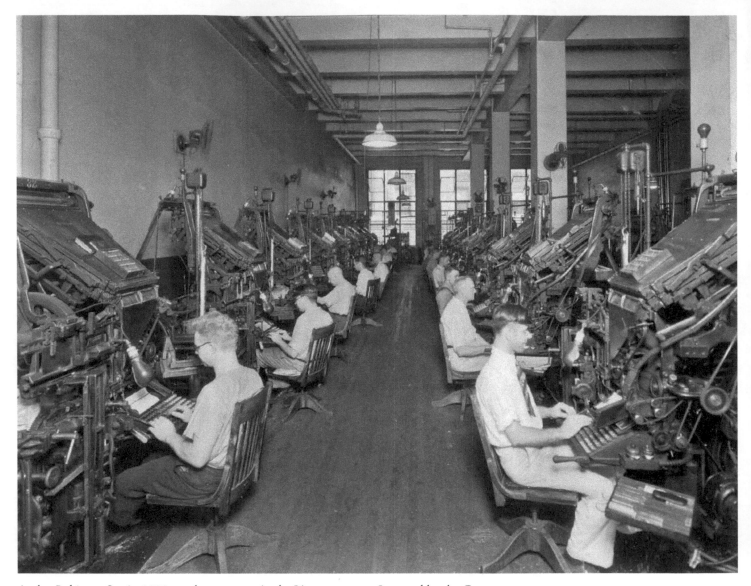

At the *Baltimore Sun* in 1930, workers set type in the Linotype room. Invented by the German immigrant Ottmar Mergenthaler, a watchmaker who set up shop on Bank Lane in Baltimore in 1883, the Linotype machine modernized the newspaper industry, which until then had relied on the much slower process of typesetting by hand. Mergenthaler built his first prototype at the Bank Lane shop, and in 1886 the *New York Tribune* became the first newspaper to use his invention.

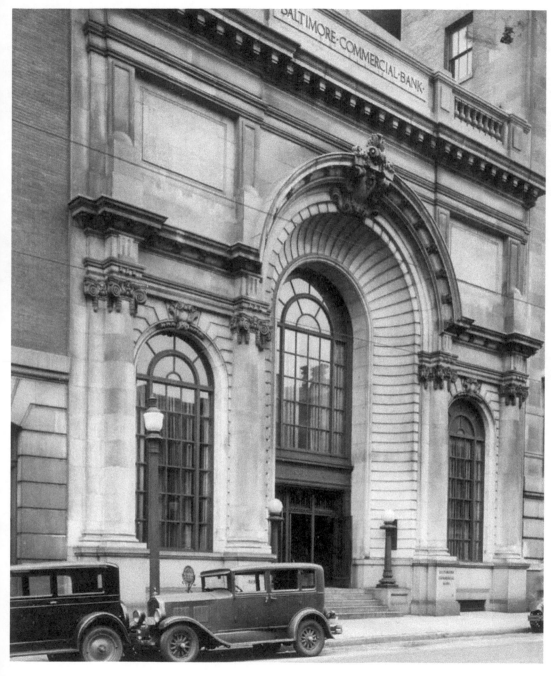

Designed by E. Francis Baldwin and Josias Pennington in the French Renaissance style and built in 1901, the Baltimore Commercial Bank Building at 26 South Street survived the Great Fire of 1904. But here in 1930, the Baltimore Commercial Bank, like all banks, faced a much different crisis—the stock market had crashed in October 1929 and the Great Depression loomed. In 1994, the historic building was acquired and renovated by the law firm Shar, Rosen and Warshaw.

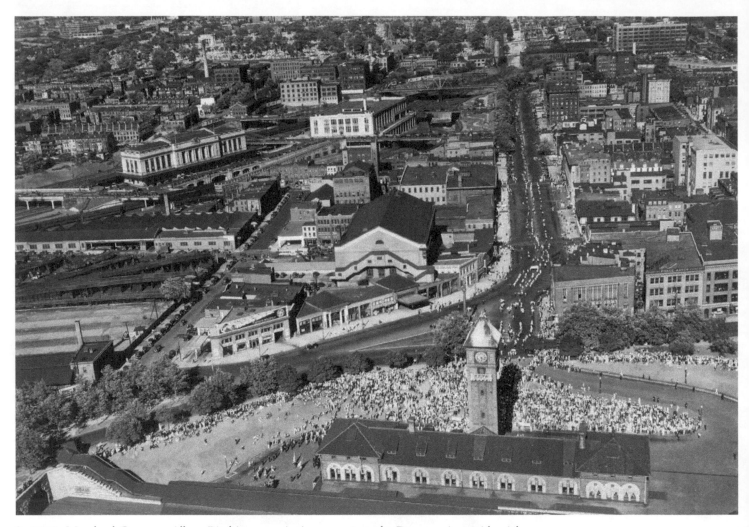

In 1932, Maryland Governor Albert Ritchie, campaigning to capture the Democratic presidential nomination, rallied his supporters in a June whistlestop at Mount Royal Station, shown here. Ritchie was unsuccessful in his bid; Franklin Delano Roosevelt became the Democratic nominee.

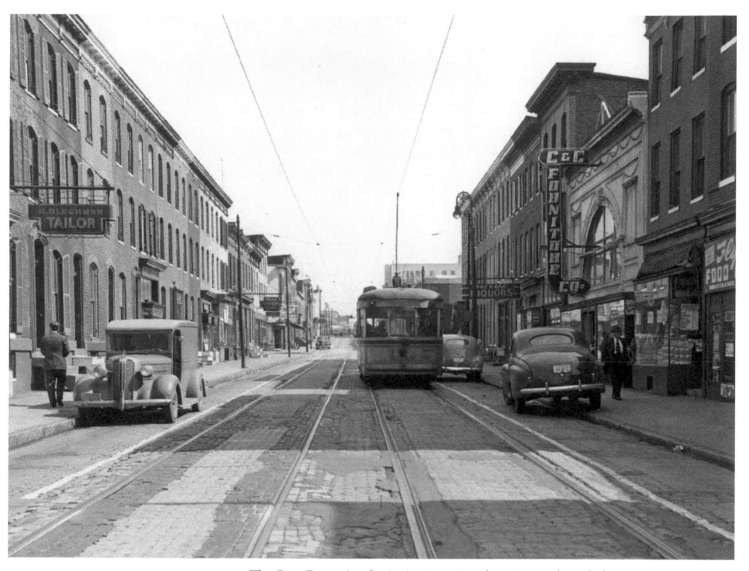

The Great Depression, beginning in 1929 and continuing through the 1930s, took its toll on downtown commercial districts, as local enterprises struggled for existence. By 1934, 29,000 Baltimoreans were officially unemployed.

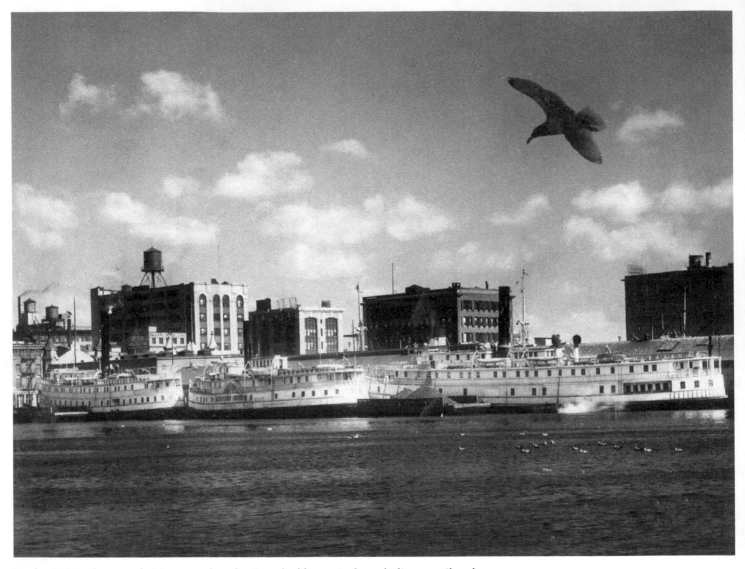

By the 1930s, the once thriving steamboat business had begun its long decline, as rail and motor transportation became more feasible, popular, and economically viable. Steamboats still lined the harbor piers, as in this 1932 view, but service lines were quickly being discontinued. Bay steamer service between larger cities would end after World War II.

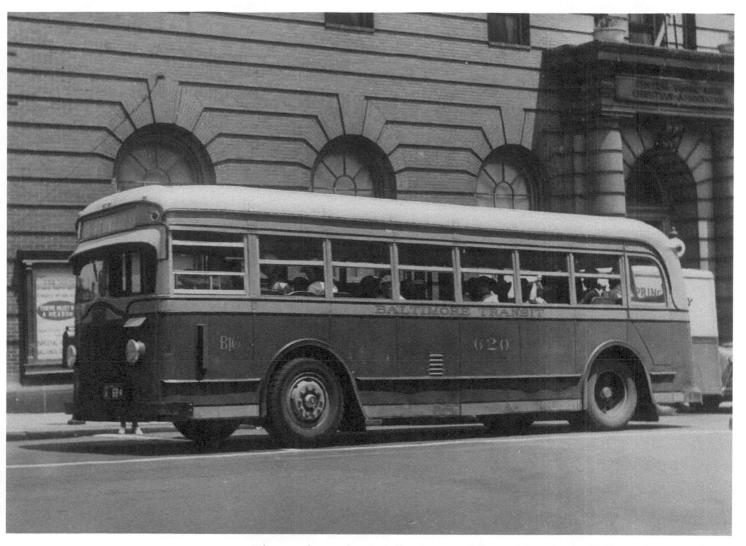

Like steamboats, electric trolleys began to fall out of favor by the 1930s, as the personal auto continued its ascendancy and the Great Depression affected ridership, with many working-class commuters finding themselves jobless. In response, the Baltimore Transit Company was formed in 1935 to try to resuscitate the declining city transit. It began by investing in a fleet of buses to replace the aging electric trolleys. In 1970, the privately owned transit company was taken over by the Maryland Transit Administration, which put all local buses under state operation.

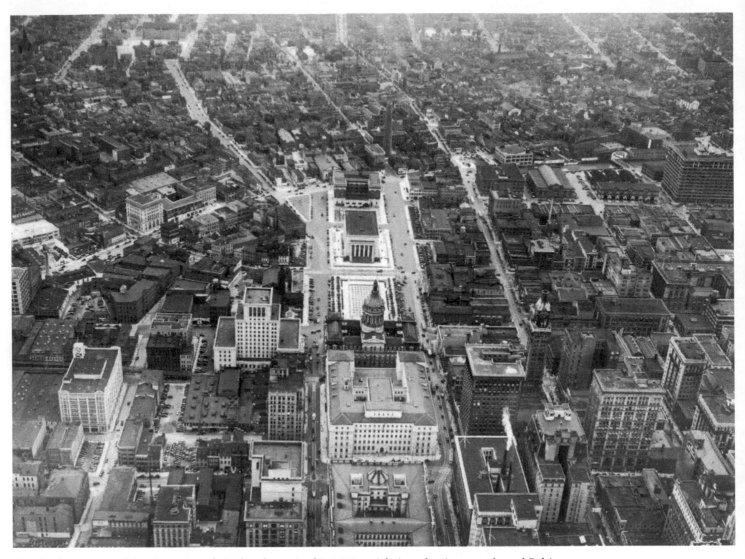

A majestic survivor of the Great Fire of 1904 and seen in this 1933 aerial view, the six-story, domed Baltimore City Hall was designed by 22-year-old architect George A. Frederick. The cornerstone was laid with great ceremony in 1867, yet the building would not be dedicated until October 1875. The segmented dome atop the building was constructed by the firm of Wendel Bollman, the Baltimore civil engineer who devised the pioneering truss system employed by iron bridges throughout the B&O system.

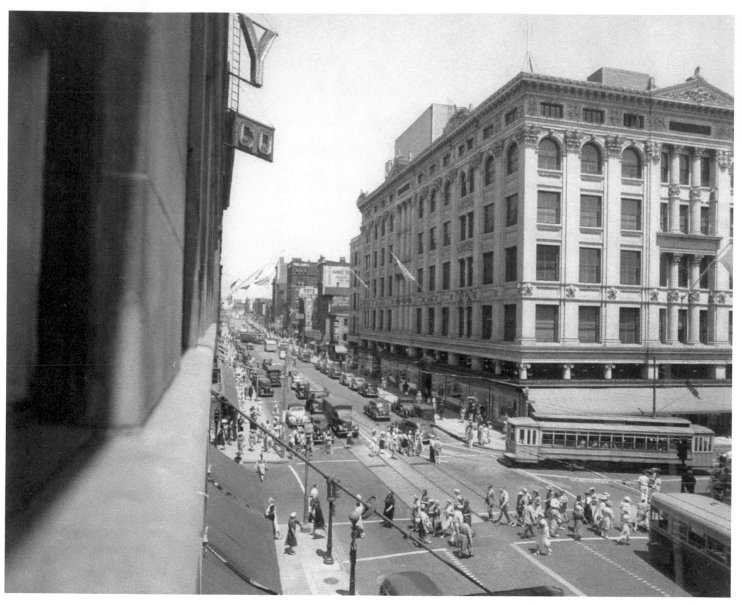

North Howard Street, anchored by the venerable Stewart's Department Store, became known as the "ladies shopping district," a name that stuck through the early twentieth century.

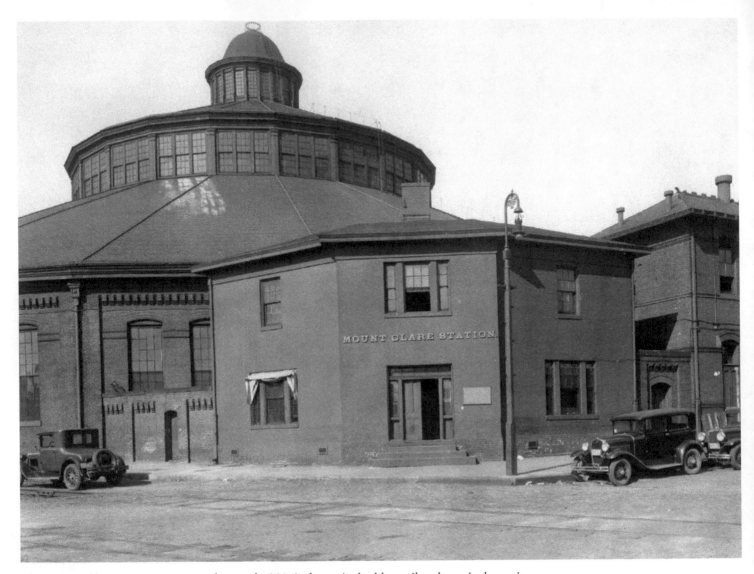

The Mount Clare station, constructed around 1830, is the nation's oldest railroad terminal, a unique polygonal building where regularly scheduled trains would begin the 13-mile trek to Ellicott Mills. Rising behind is the Passenger Car Roundhouse, designed by E. Francis Baldwin and completed in 1884. The roundhouse consists of 22 equal sides, creating a nearly circular brick structure into which trains on 22 separate tracks entered, rerouted, and exited. On May 24, 1844, the nation's first telegraph message, sent by Samuel Morse from Washington, D.C., was received at the station.

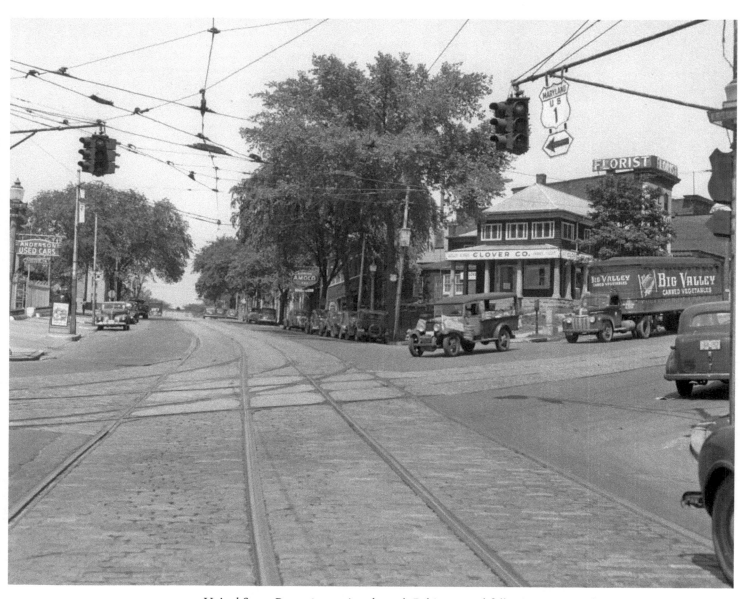

United States Route 1, running through Baltimore and following nineteenth-century paths in and out of the city, was first paved by the State of Maryland in 1914 and was officially named U.S. 1 with the creation of the national highway system in 1926. Autooriented services quickly sprang up along the route to cater to passing motorists.

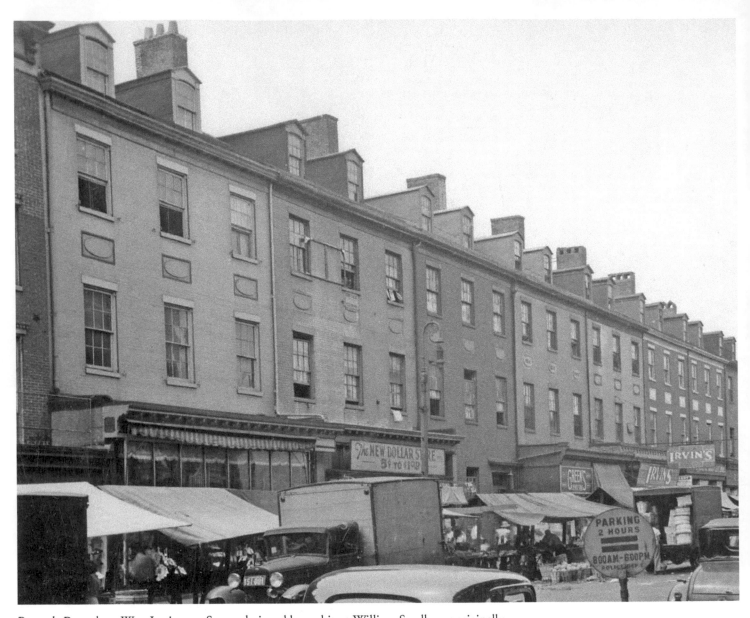

Pascault Row along West Lexington Street, designed by architect William Small, was originally developed by Jean Charles Marie Louis Felix Pascault, Marquis de Poleon, as speculative houses on his estate Chatsworth. Once a distinctive residential enclave for prominent Baltimoreans, the row by the 1930s had taken on a decidedly commercial appearance.

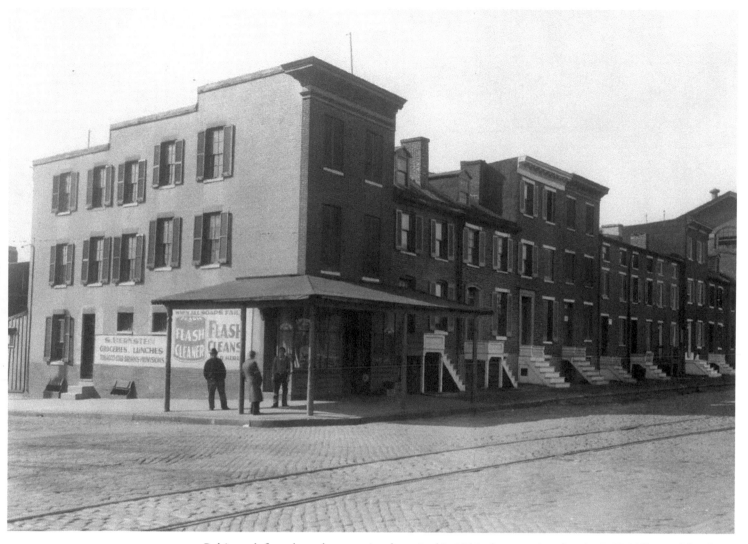

Baltimore's famed row house stairs gleam in this 1933 photograph, taken by J. K. Hillers, of dwellings in the vicinity of Mount Clare Depot. Flash Cleaner, advertised on the side of Bernstein's store, holds the distinction of producing one of the nation's earliest motion-picture commercials, filmed by Thomas Edison around 1920.

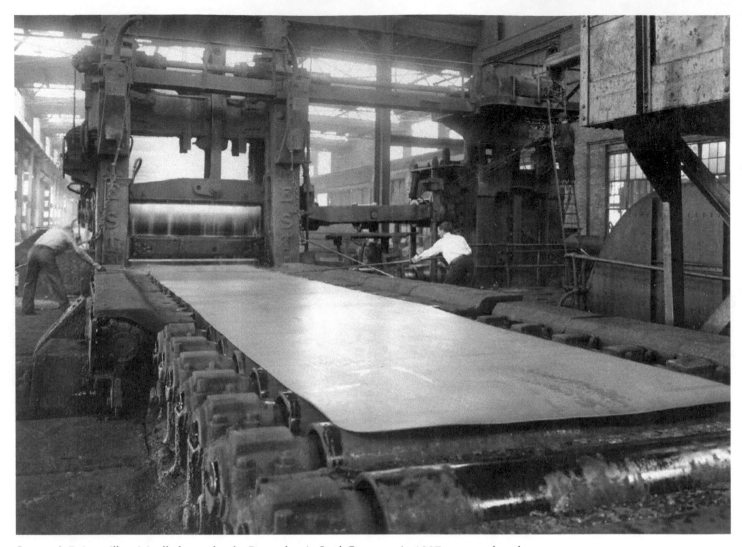

Sparrow's Point mill, originally begun by the Pennsylvania Steel Company in 1887, was purchased by the Bethlehem Steel Company in 1916 and, by midcentury, had become the world's largest steel mill, sprawling for four miles and employing tens of thousands of Baltimoreans. Steel produced at the facility was used to fashion prominent features of some of the nation's most notable structures, including the girders of the Golden Gate Bridge in San Francisco and the cables in New York's George Washington Bridge.

A policeman helps direct traffic along Lexington Street in 1935.

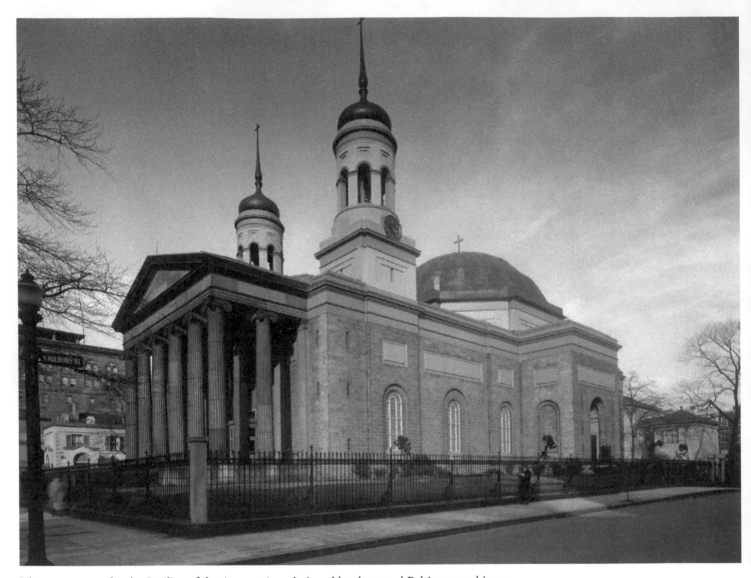

The cornerstone for the Basilica of the Assumption, designed by the noted Baltimore architect Benjamin Henry Latrobe, was laid in July 1806, but construction progressed slowly. In 1821, its towers and porch still unfinished, the Cathedral of the Assumption of the Blessed Virgin Mary was formally dedicated. The onion-shaped domes, seen here in the 1930s, were added to the towers in 1832; in the 1870s Latrobe's grandson, John H. B. Latrobe, would oversee erection of the porch.

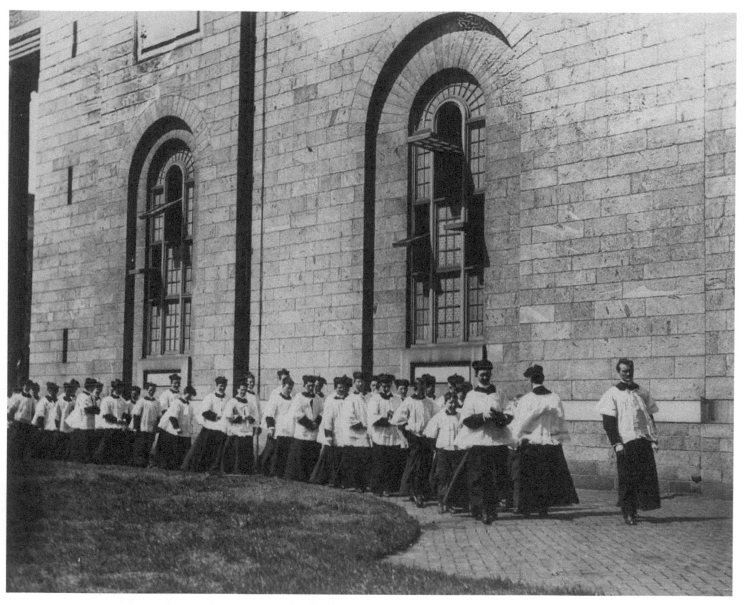

Pope Pius XI officially elevated the Cathedral of the Assumption to basilica status in the fall of 1937, not long after this photo was taken.

The Mount Vernon Place Methodist Episcopal Church, completed in 1872 and seen here in 1936, was constructed of six different types of stone, including green serpentine marble quarried at the nearby Falls. Major repair and replacement work was done on the stone in 1932.

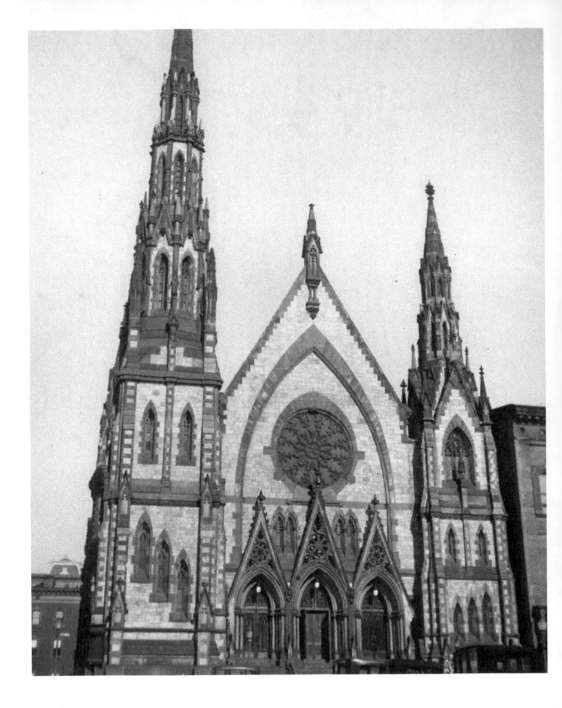

In the 1930s, patrons of the shop occupying this modest nineteenth-century building at the corner of South Broadway and Shakespeare streets could pick up a Coca-Cola and a copy of *True Story* magazine, begun in 1919 by the eccentric publisher Bernarr Macfadden and offering lurid tales of crime and infidelity.

Waterloo Row, reportedly named after the place of Napoleon's final defeat, was designed by the noted architect Robert Mills. When built between 1817 and 1819, they were the most expensive row houses in Baltimore, priced at a staggering $8,000.

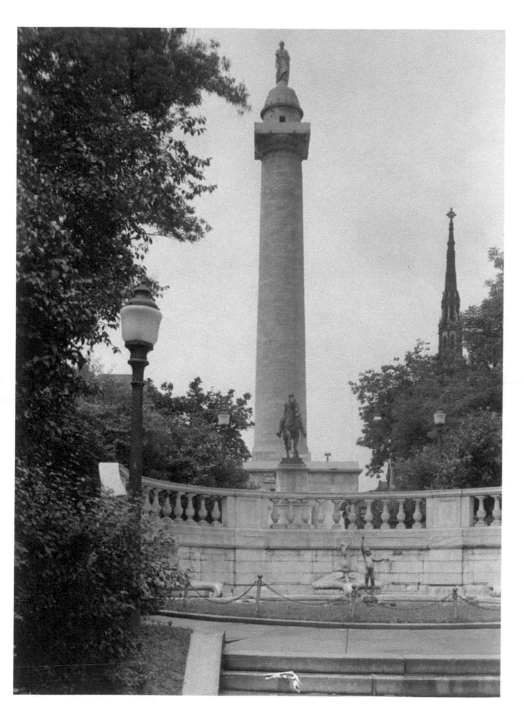

Mount Vernon Place, surrounding the Robert Mill–designed Washington Monument, was adorned by numerous bronze sculptures over the years, the last major piece being an equestrian statue of the Marquis de Lafayette, dedicated in 1924 to the memory of American and French comrades who fell in World War I.

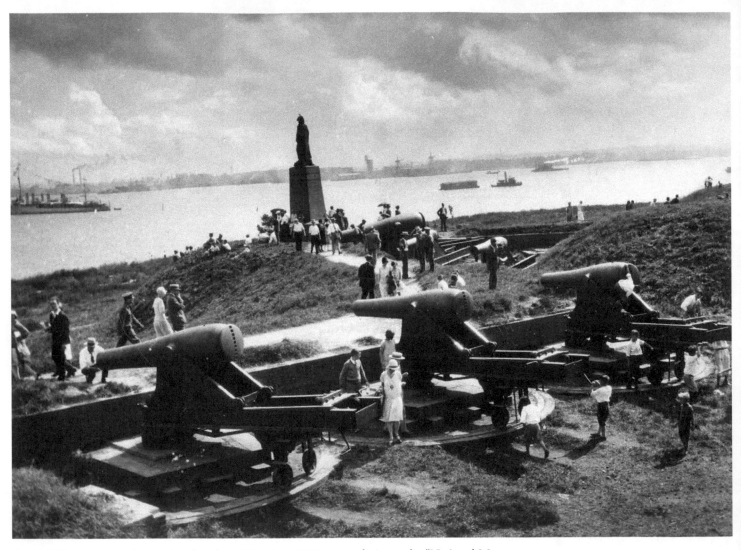

Fort McHenry was made a national park in 1925; in 1939 it was redesignated a "National Monument and Historic Shrine," the only such site in the United States.

Intricate cast-iron work adorns the balcony of a nineteenth-century building on the northwest corner of Exeter and Watson streets. Baltimore by the 1850s was a leading center for the manufacture of both structural and decorative cast iron; the local firm of Poole and Hunt created the cast-iron columns and much of the ironwork for the dome of the United States Capitol, completed in 1866.

Seen here in 1936, the President Street Station of the Philadelphia, Wilmington and Baltimore Railroad was completed in 1850 and served as the line's southern terminal. Passengers continuing onward had to debark at the station and travel crosstown to pick up another southbound train. On April 19, 1861, the Sixth Massachusetts Volunteer Militia Regiment arrived at the station and, as they traveled along Pratt Street toward the B&O's Camden Station, were attacked by an angry mob of Southern-sympathizing citizens. After the attack, 4 soldiers and 12 Baltimoreans lay dead in the street, the first bloodshed of the Civil War.

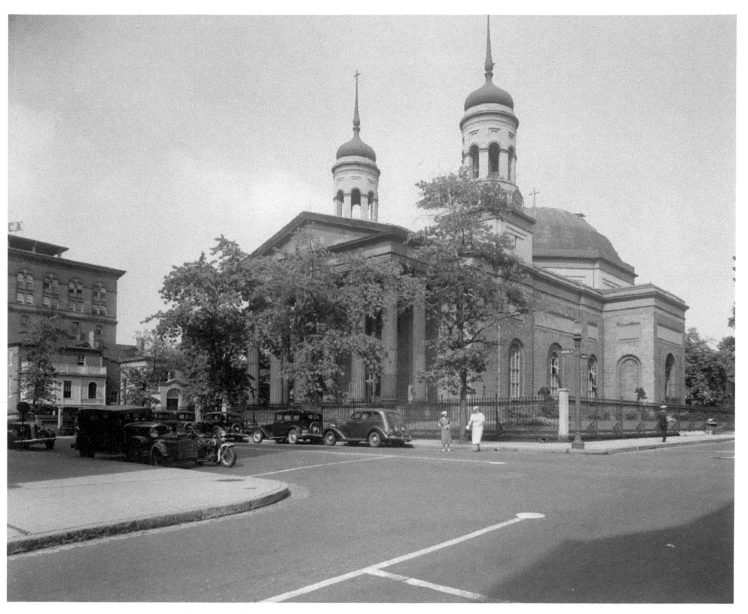

Consecrated in 1821 and seen here in 1936, the Basilica of the Assumption, designed by Benjamin Henry Latrobe, was declared "the finest classical church in America" by Fiske Kimball, the noted American architect and critic.

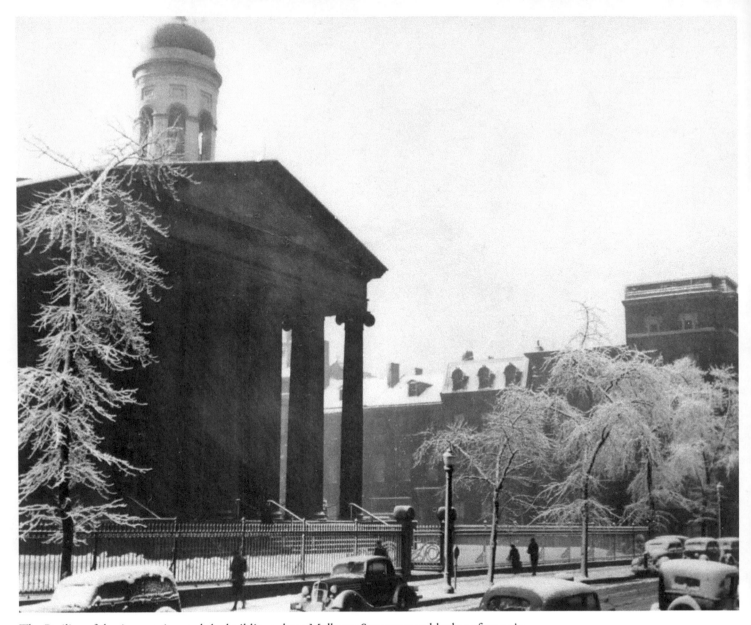

The Basilica of the Assumption and the buildings along Mulberry Street wear a blanket of snow in February 1937.

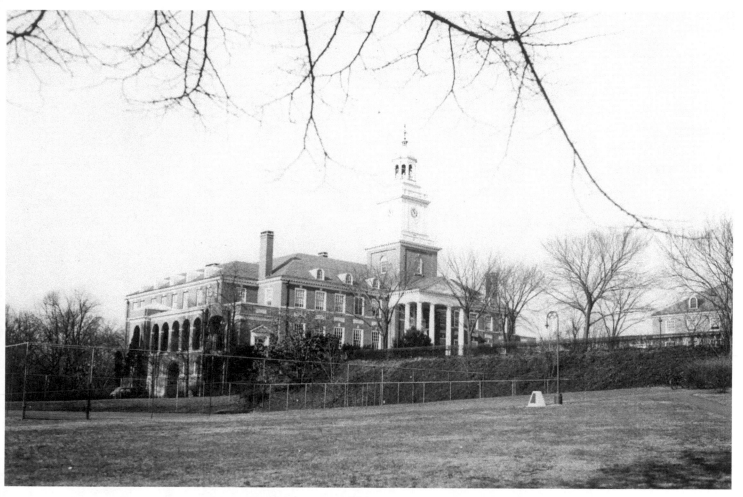

Johns Hopkins University opened on February 22, 1876, with the inauguration of its first president, Daniel Gilman. The school was something entirely new to the American educational system—a research university offering Ph.D.s and dedicated not only to advancing its students' knowledge but to faculty research for the benefit of all humanity. In 1904, the university undertook an ambitious reworking of its overall campus design. The first major academic building on the new campus would be Gilman Hall, designed by the firm of Parker, Thomas and Rice. Dedicated in 1915 and named for the first president, it is seen here in 1941.

Latrobe Hall on the campus of Johns Hopkins University was designed by Joseph Evans Sperry and occupied in the fall of 1916 by the civil engineering department. In 1931 the building was renamed Latrobe Hall to honor the noted Baltimore engineer Benjamin Henry Latrobe, Jr., the chief engineer of the B&O Railroad at the end of the nineteenth century

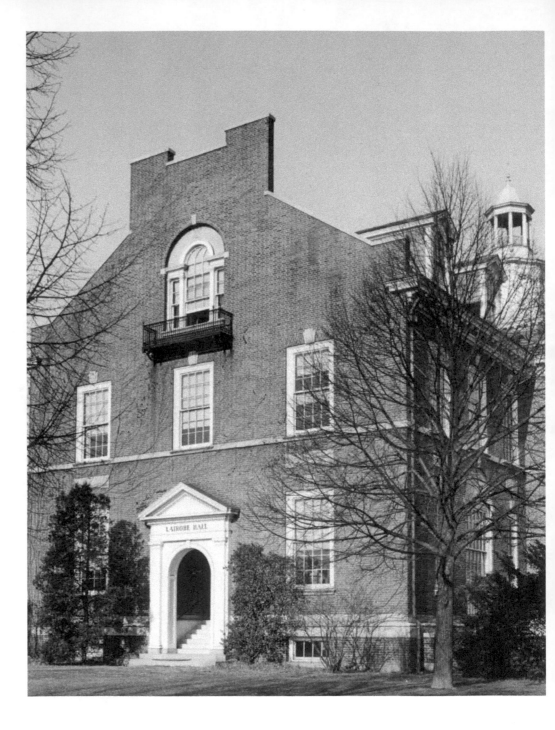

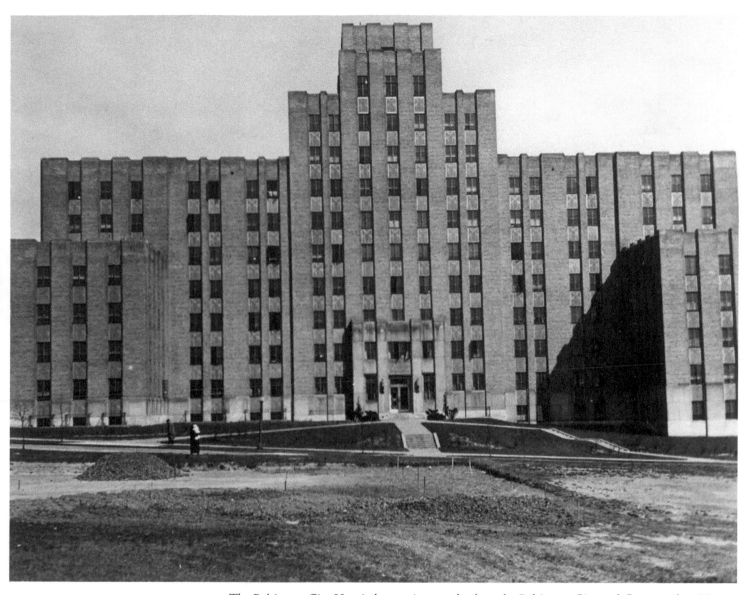

The Baltimore City Hospital traces its roots back to the Baltimore City and County Alms House, established in 1773 to house the poor. In 1866, the Alms House relocated to 240 acres overlooking the Chesapeake and by 1925 had grown into the Baltimore City Hospitals. In 1935, the City Hospitals completed a state-of-the-art, 450-bed general hospital, seen here shortly after its opening.

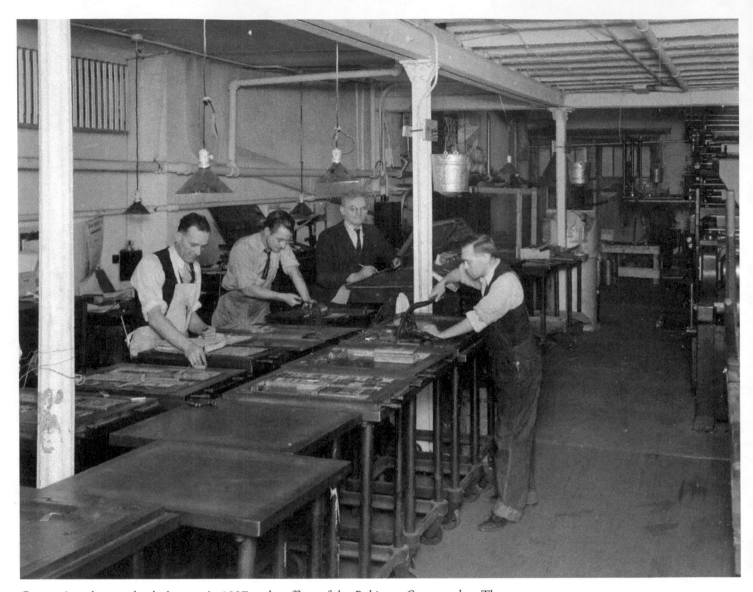

Compositors lay out the day's paper in 1937 at the offices of the *Baltimore Correspondent*. The newspaper, also known as the *Taglicher Baltimore Correspondent*, began publication in 1935 and appeared chiefly in German with some English, continuing a string of German-language newspapers that appeared in the city after World War I.

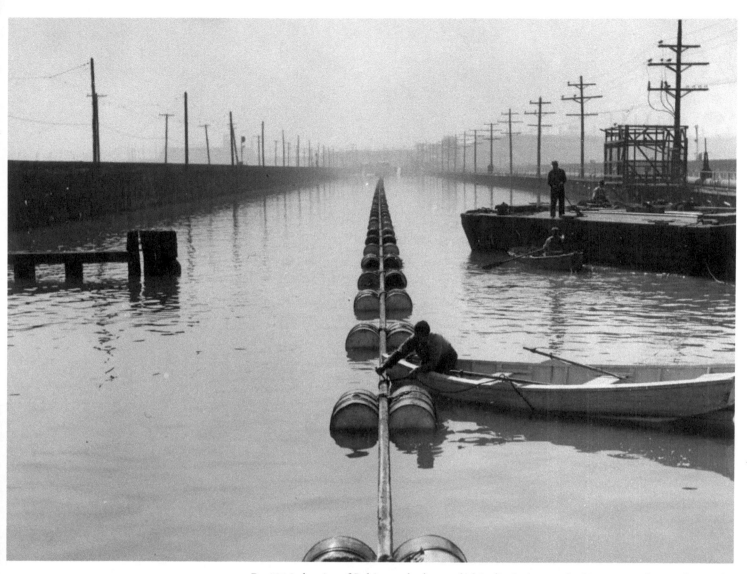

By 1918 the city of Baltimore had extended its limits by nearly 60 square miles, and over the succeeding decade the Baltimore Gas and Electric Company—formerly known as the Consolidated Gas Electric Light and Power Company of Baltimore—rushed to expand its gas and electric lines to meet the service demands of the outlying portions of the city to the north and south, across the Patapsco. Here in 1937, workers attend to a floating pipeline.

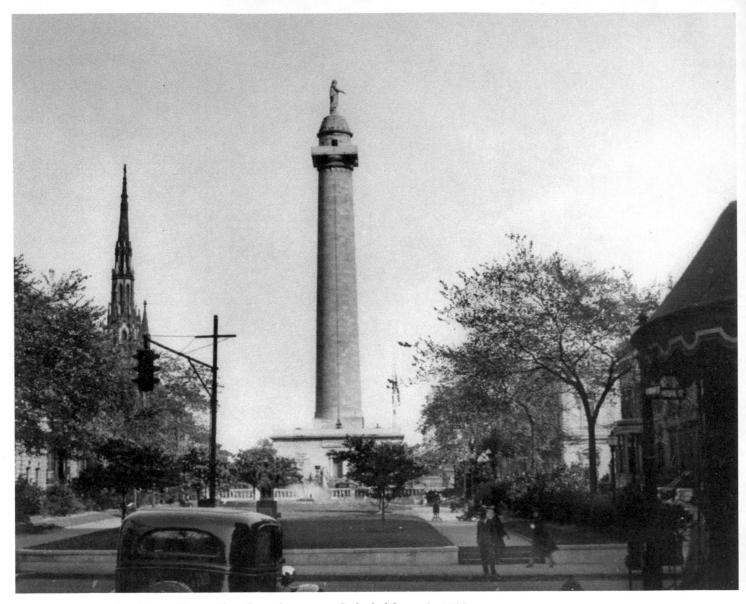

A motorist approaches Mount Vernon Place from the west, at Cathedral Street, in 1938.

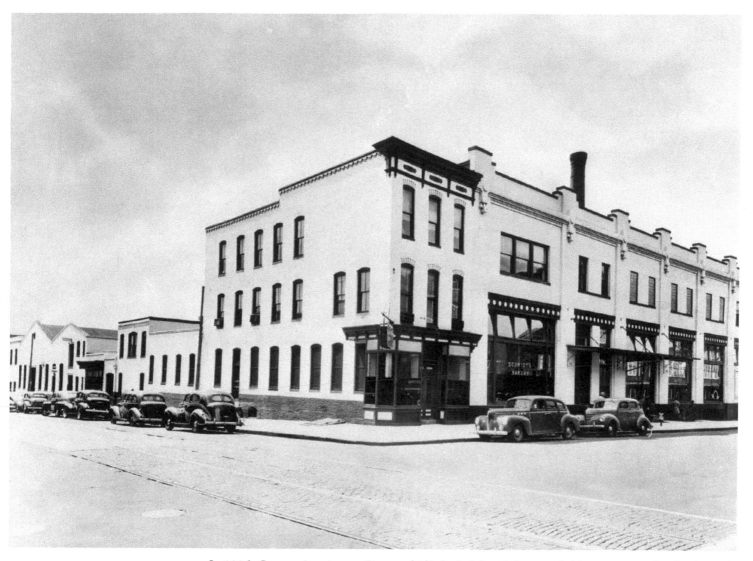

In 1886, German immigrants Peter and Elizabeth Schmidt began a baking company that by the early twentieth century had grown into one of the Mid-Atlantic's largest independent bakeries. In 1914, they opened this state-of-the-art bakery on Laurens Street, capable of turning out 500,000 loaves of bread every six days.

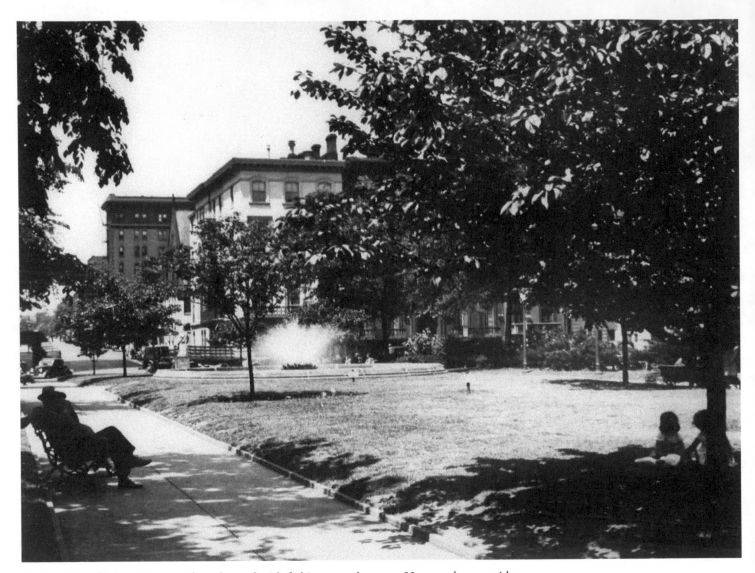

Landscaping of Mount Vernon Place changed with fashion over the years. Here on the west side, Robert Garrett, president of the B&O Railroad, and art collector William Walters landscaped the square in 1884 with bronze statues and a round fountain. These local residents are enjoying the square's shade in 1939.

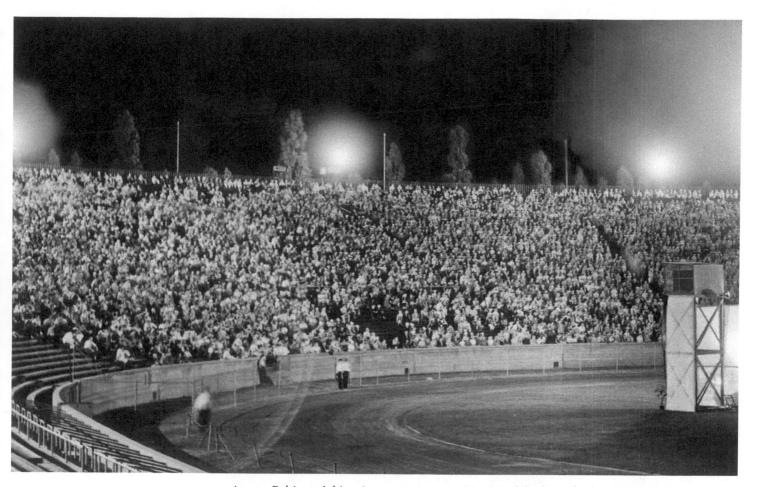

Among Baltimore's historic sports arenas was Municipal Stadium, built in 1922 along 33rd Street in a previously undeveloped area called Venable Park. A large horseshoe of a stadium with an open southern exposure, the stadium in its early years saw primarily football action, hosting various college-level matches including the 1924 Army-Navy game. Seen here in 1939, the stadium was pressed into service as a park for the Orioles in 1944 when the baseball team's previous home was destroyed by fire. In 1950, the stadium was razed to make way for Memorial Stadium.

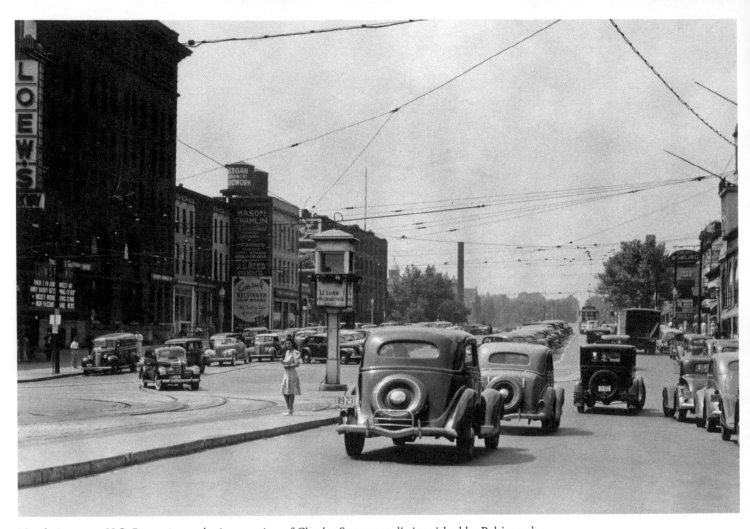

North Avenue—U.S. Route 1—at the intersection of Charles Street was distinguished by Baltimore's first traffic light, contained in the kiosk on the pole standing in the median. At first, the light was manually operated by a policeman stationed in the booth; in 1928, it became automated.

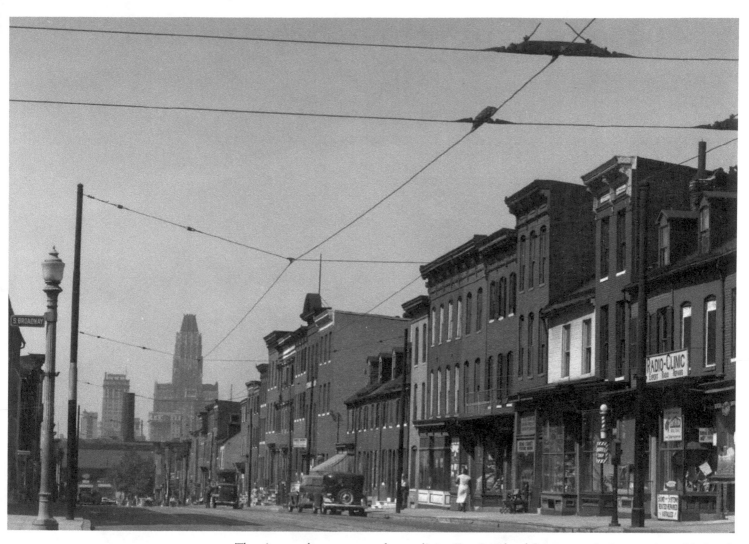

The nineteenth-century row houses lining East Lombard Street, near its intersection with South Broadway, are dwarfed by the looming presence in the distance of the Baltimore Trust Building, which broke ground for its new office in 1924 at the corner of Light and vBaltimore streets. The 34-story, 509-foot structure opened five years later.

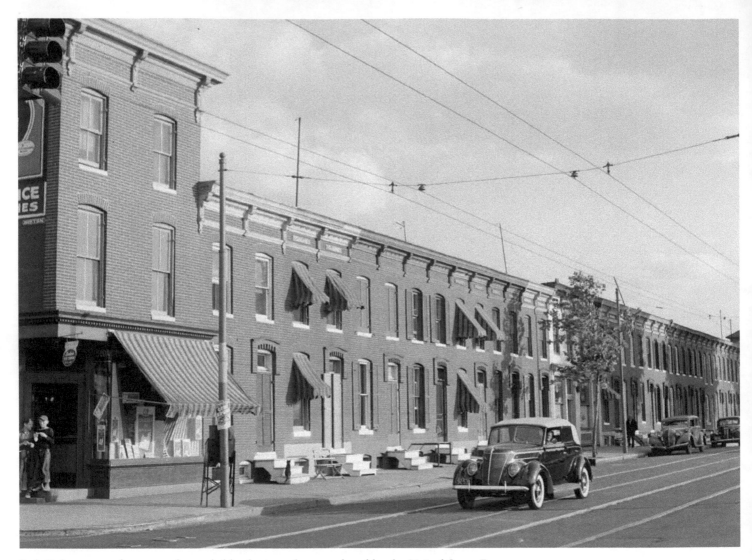

Jack Delano, one of a group of remarkable photographers employed by the United States Farm Security Administration during the 1930s and early 1940s to document the effects of the Great Depression, took this shot of a quintessential string of Baltimore row houses in June 1940. Other photographers working for the FSA included Walker Evans, Dorothea Lange, and Gordon Parks.

LIBERTY SHIPS TO HARBORPLACE

(1940–1950s)

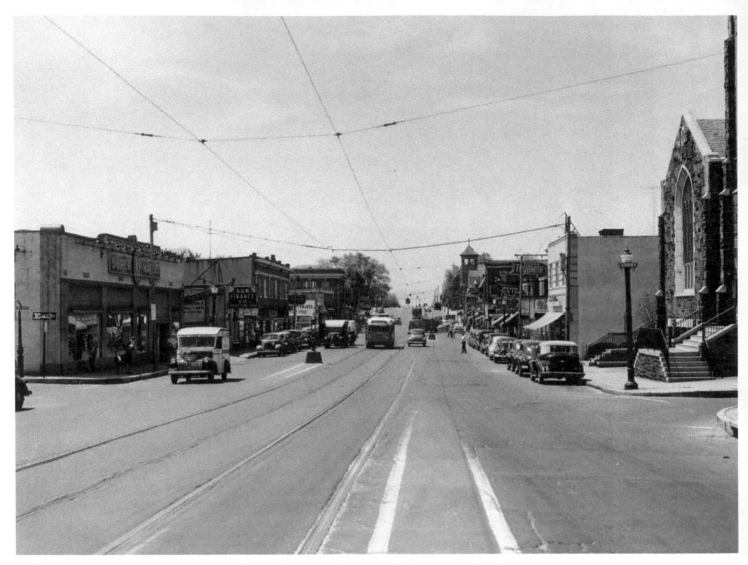

In the early twentieth century, locally owned shops began to give way to chain stores, such as the A&P Super Market in the left foreground. One of the chain's strongest markets, Baltimore at one time boasted four A&Ps—on Broadway, South Broadway, West Baltimore, and North Eutaw streets. By the 1930s, the chain had grown to 15,000 stores nationwide.

The Baltimore College of Dental Surgery, chartered by an act of the Maryland General Assembly in 1840, is the world's first dental school. In 1940, the school—today a part of the University of Maryland system—celebrated its centennial with displays of salient moments in dental history, including a reconstruction of the college's original home.

During World War II, Liberty ships, created by the United States to transport cargo to fighting forces around the globe, were turned out at an amazing pace. Eighteen American shipyards built 2,751 Liberties between 1941 and 1945. Foremost among the builders was Baltimore's Bethlehem- Fairfield shipyard, whose innovations in mass production reduced the amount of time required to build a ship from 244 days to less than 30 days. Key to the innovation was prefabricating and welding parts for the Liberty ships, undertaken at this former freight-car production site

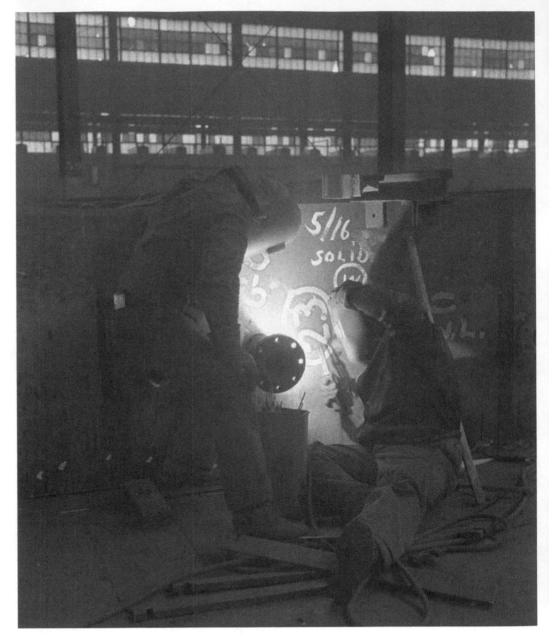

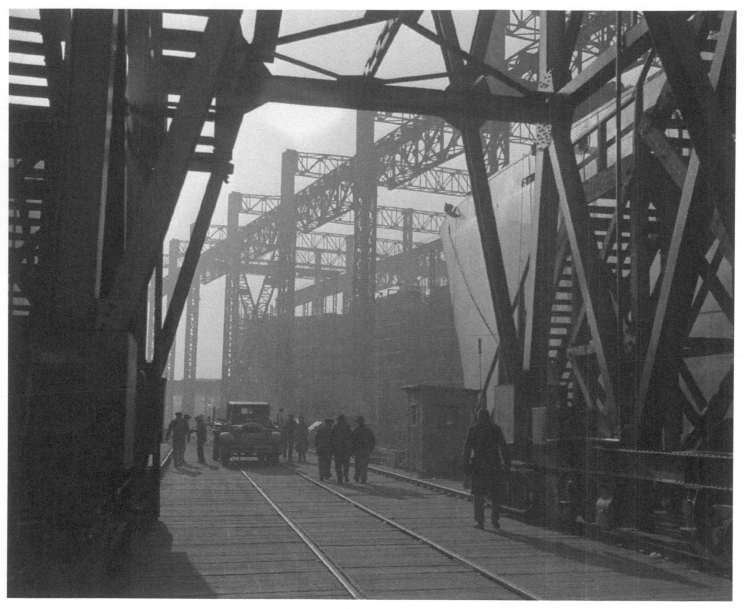

The completed sections of the Liberty ship were loaded onto flatcars and carried six miles to the dry docks where the ships were assembled.

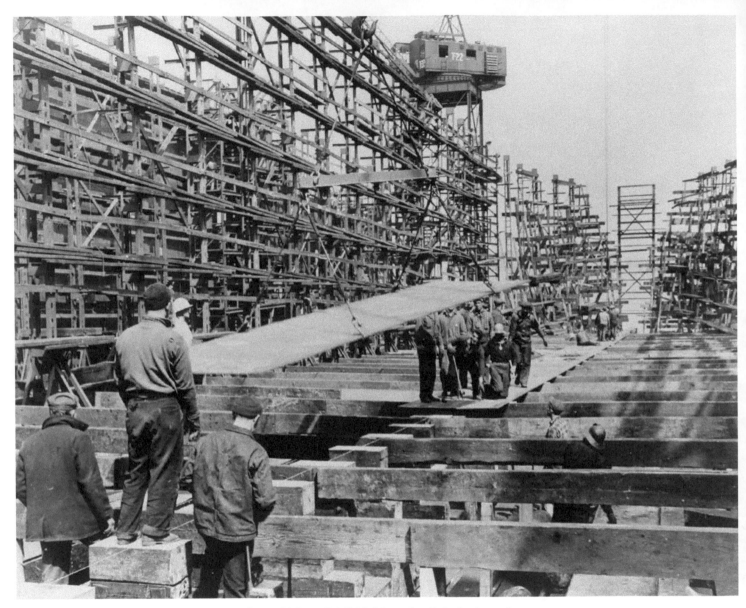

On the second day of a ship's production at the Bethlehem-Fairfield shipyards, all the horizontal beams were laid and keel blocks set at the proper pitch.

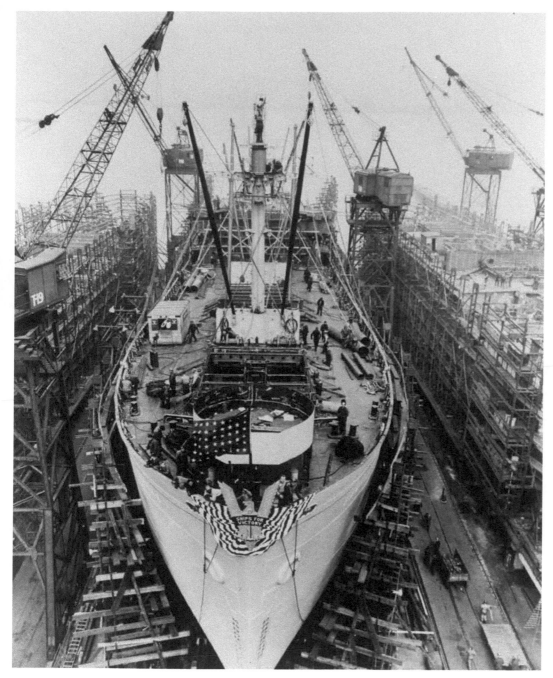

On the twenty-fourth day of production, a Liberty ship such as this one would be ready for launching—with the christening platform in place. On September 27, 1941, the nation's first Liberty ship, the *Patrick Henry*, was launched from the Bethlehem-Fairfield Shipyard.

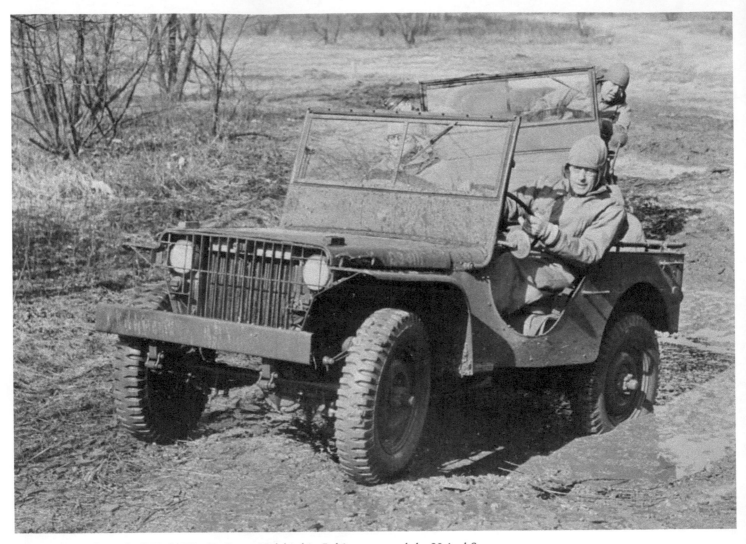

From 1941 to the end of World War II, Camp Holabird in Baltimore served the United States Army as a training and testing center for military transports. Home of the service's Quartermaster Mechanical Repair Unit, the camp encompassed some 350 acres and 286 buildings. In 1940, the camp was the site of field testing for a new type of vehicle, a lightweight alternative to bulky military trucks that often got stuck in the mud. The vehicle became known as the "Jeep." Here, in 1942, Colonel H. J. Lawes, post commander, gives his pupils firsthand instructions in handling the new vehicle, demonstrated on the camp's training ground.

In 1928, aircraft pioneer Glenn L. Martin was lured to Baltimore by promises of a new municipal airport, ice-free water for seaplanes, and union-free labor. The plant he established in Middle River, northeast of the city, became a key part of America's "arsenal of democracy" during World War II, producing among other things the Martin Model 167 plane—known as the "Maryland"—that saw action with the French and British forces. Here, as part of the war effort, the plant's personnel manager joins a carpool to save gasoline and rubber.

For coastal cities like Baltimore, with extensive shipbuilding and airplane facilities, air raids were regarded as a major threat. As the sign in the window of this bus indicates, if the warning signals sounded, passengers were required to leave the conveyance and seek shelter, though they could request a fare voucher good for reboarding anywhere for half an hour "after the second 'Blue' signal," which was the signal indicating danger had passed, at least for the moment.

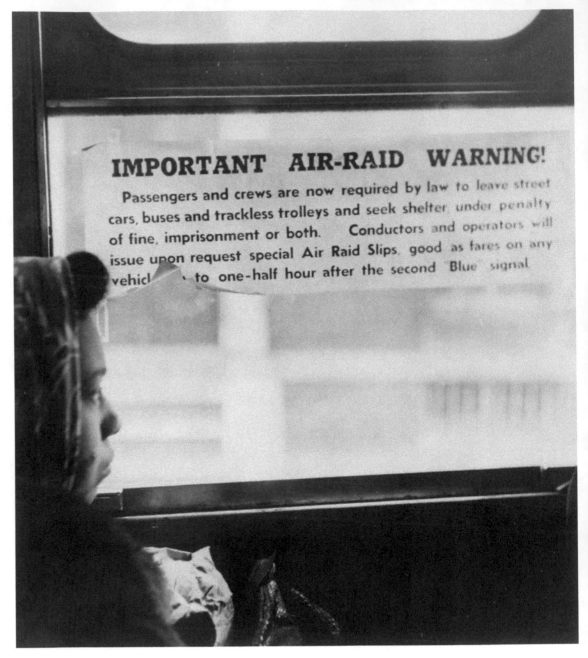

IMPORTANT AIR-RAID WARNING!

Passengers and crews are now required by law to leave street cars, buses and trackless trolleys and seek shelter, under penalty of fine, imprisonment or both. Conductors and operators will issue upon request special Air Raid Slips, good as fares on any vehicl to one-half hour after the second 'Blue' signal

With the onset of World War II, the United States government found it necessary to ration food, gas, rubber, metal, even clothing, all to ensure that a steady stream of supplies could be directed toward the war effort. Hard hit were the commercial establishments of downtown Baltimore, where quiet streets reflected the lack of goods and customers.

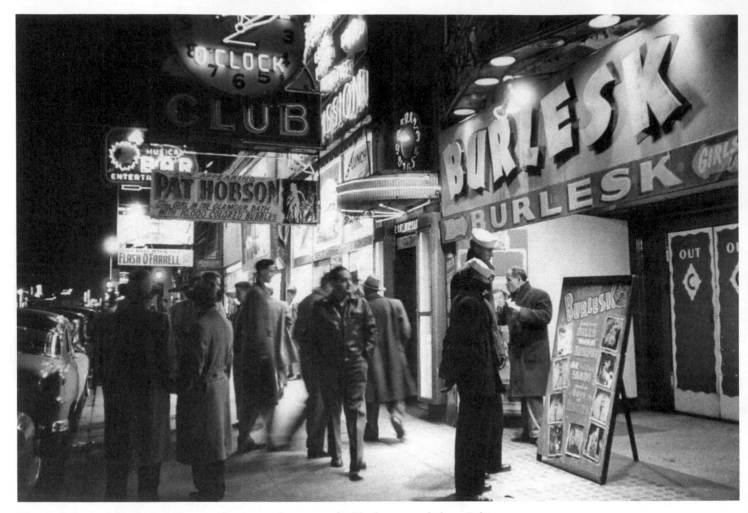

The city's free-swinging entertainment district was known as the Block, centered along Baltimore Street between Guilford Avenue and the Fallsway. In 1906, the Gayety Theatre opened, becoming a popular spot on the American burlesque circuit. By the 1940s it had been joined by a glittering mix of all-night restaurants, peep show emporiums, and cabarets such as the Oasis, the Pussy Cat, and the Two O'clock Club, the latter seen here featuring Pat Hobson, "The Girl in the Glamour Bath with 10,000 Colored Bubbles."

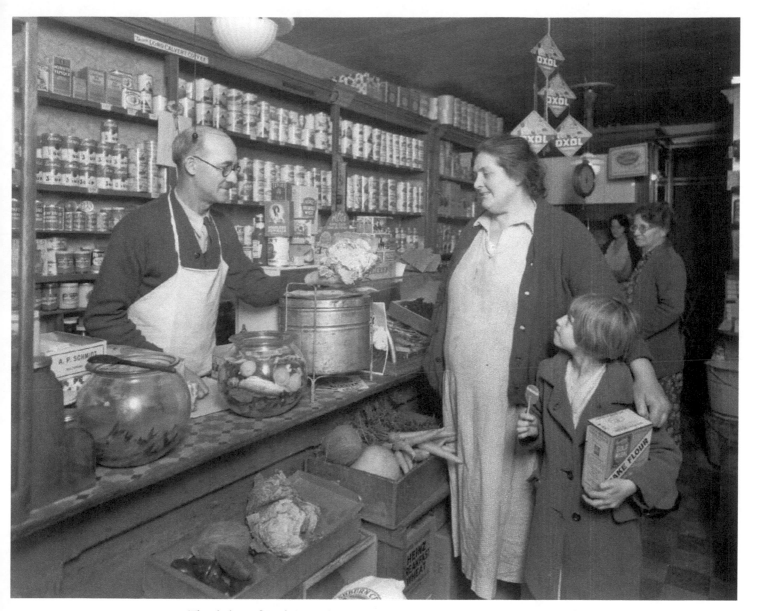

The shelves of Fred Grouer's grocery store on Hare Street are filled with Baltimore's best canned products.

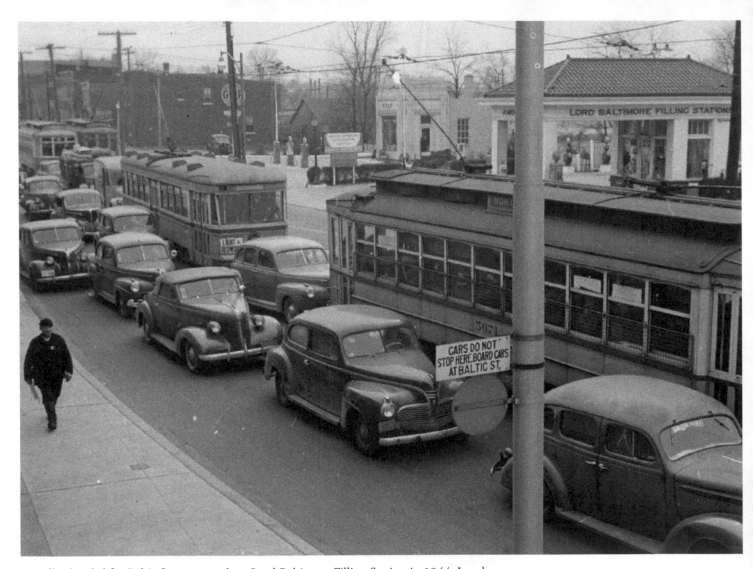

A trolley headed for Baltic Street passes by a Lord Baltimore Filling Station in 1944. Local
entrepreneur Louis Blaustein incorporated the chain of area stations in 1921 to market the petroleum
products of his American Oil Company, which he formed in 1911 and nicknamed "Amoco." Blaustein
pioneered such innovations as one of the first visible globe gasoline pumps—which allowed customers
to actually see the gas they were pumping—along with unleaded gasoline and the drive-in station.
In 1954, Blaustein's oil company and his service station chain were merged into the Standard Oil
Company of Indiana, which eventually adopted his Amoco name.

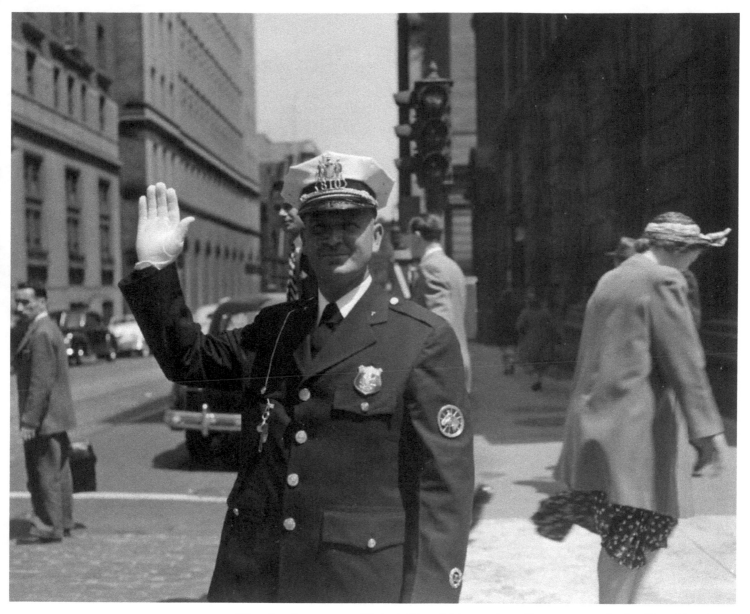

Directing downtown traffic in 1948, a Baltimore city policeman wears the familiar white gloves, adopted to bring visibility to hand signals.

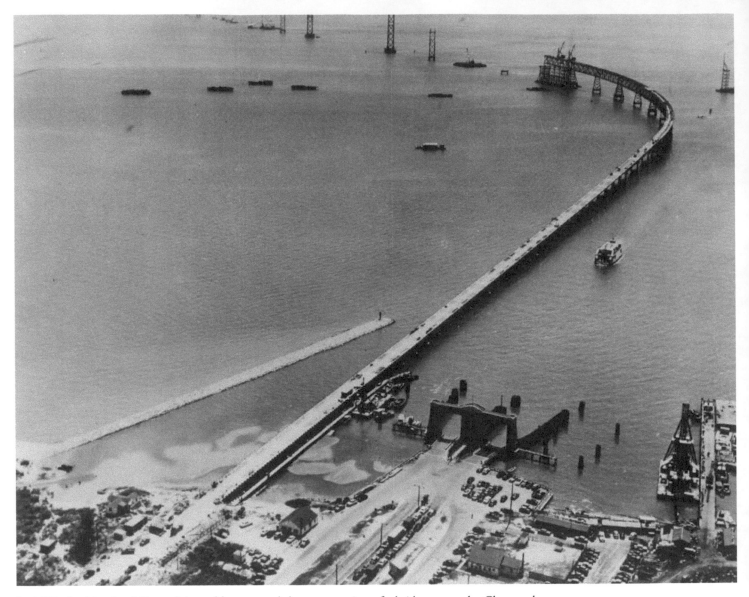

In 1938, the Maryland General Assembly proposed the construction of a bridge across the Chesapeake Bay, from Sandy Point on the Western Shore to Kent Island on the Eastern Shore, to replace the private automobile ferries that had run since the early twentieth century. World War II delayed construction until 1949, when ground was finally broken and work commenced.

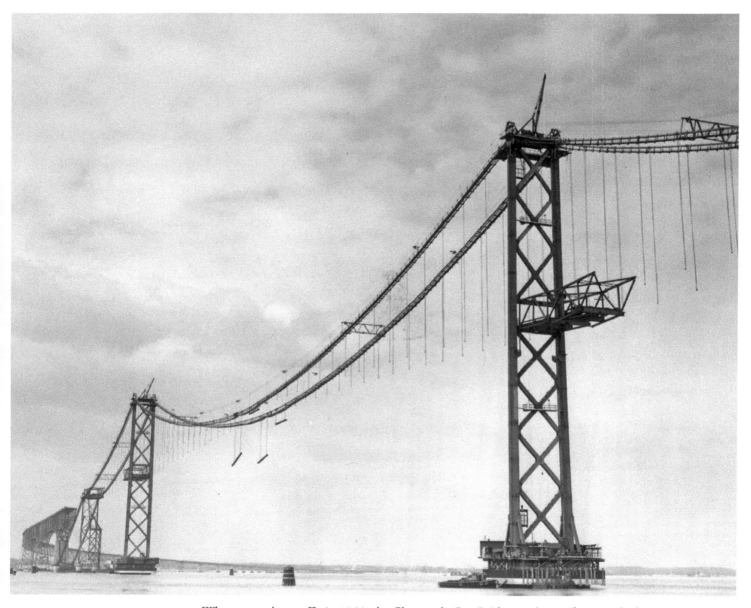

When opened to traffic in 1952, the Chesapeake Bay Bridge, at 4.32 miles, was the longest continuous over-water steel structure and third-longest bridge in the world.

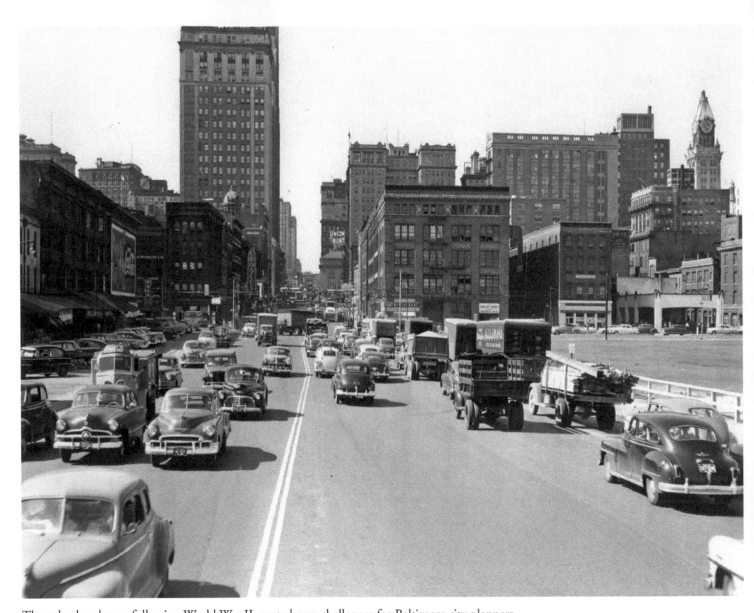

The suburban boom following World War II created new challenges for Baltimore city planners, who had to contend with a steadily increasing flow of commuters driving to downtown offices—and creating the city's first rush-hour traffic jams. In 1952, a study was commissioned to document the conditions. Here, heavy traffic moves along Light Street between 3:30 and 5:00 P.M.

Notes on the Photographs

These notes, listed by page number, attempt to include all aspects known of the photographs. Each of the photographs is identified by the page number, a title or description, photographer and collection, archive, and call or box number when applicable. Although every attempt was made to collect all data, in some cases complete data may have been unavailable due to the age and condition of some of the photographs and records.

II ATHENAEUM CLUB
Library of Congress
HABS MD,4-BALT,30-1

VI GILMORE HOUSE
Courtesy of Enoch Pratt
Free Library, Central
Library State Library
Resources Center,
Baltimore, Maryland
EPFL-md1464

X METHODIST EPISCOPAL
CHURCH
Courtesy of Enoch Pratt
Free Library, Central
Library/State Library
Resources Center,
Baltimore, Maryland
EFPL-s211

2 VIEW OF HARBOR FROM
FEDERAL HILL
Library of Congress
LC-USZ62-13366

3 MOUNT VERNON–
WOODBERRY MILL
Courtesy of Enoch Pratt
Free Library, Central
Library State Library
Resources Center,
Baltimore, Maryland
EFPL-I365

4 UNION BANK OF MARYLAND
Library of Congress HABS
MD,4-BALT,52-1

5 PIER 2
Courtesy of Enoch Pratt
Free Library, Central
Library State Library
Resources Center,
Baltimore, Maryland
EFPL-p679

6 LEXINGTON MARKET
Library of Congress LC-USZ62-15860

7 THE SUN NEWSPAPER
BUILDING
Courtesy of Enoch Pratt
Free Library, Central
Library State Library
Resources Center,
Baltimore, Maryland
EFPL-p861

8 FOUNTAIN ON EUTAW
STREET
Courtesy of Baltimore
Camera Club; Courtesy of
Enoch Pratt Free Library,
Central Library/State
Library Resources Center,
Baltimore, Maryland
EPFL-h109

9 FIRST BAPTIST CHURCH
Library of Congress HABS
MD,4-BALT,37-1

10 BUILDING AT LIBERTY AND
GERMAN STREETS
Courtesy of Baltimore
Camera Club; Courtesy of
Enoch Pratt Free Library,
Central Library State
Library Resources Center,
Baltimore, Maryland
EPFL-h004

11 CENTER MARKET
Library of Congress
LC-DIG-ppmsca-12326

12 PEABODY INSTITUTE
Library of Congress
LC-DIG-det-4a09471

13 WASHINGTON MONUMENT
Library of Congress
LC-DIG-det-4a29716

14 BALTIMORE CITY COLLEGE
Courtesy of Enoch Pratt
Free Library, Central
Library State Library
Resources Center,
Baltimore, Maryland
EFPL-b274

15 FIRST METHODIST
EPISCOPAL CHURCH
Courtesy of Enoch Pratt
Free Library, Central
Library State Library
Resources Center,
Baltimore, Maryland
EFPL-t202

16 LEXINGTON MARKET
Library of Congress
LC-D4-43299

17 BOSTON STREET BRIDGE
Library of Congress HAER
MD,4-BALT,188-16

18 UNLOADING BANANAS
Library of Congress
D4-18502

19 HOTEL KERNAN
Library of Congress
D4-19127

20 POLICE GUIDING CARTS
AFTER FLOOD
Courtesy of Enoch Pratt
Free Library, Central
Library State Library
Resources Center,
Baltimore, Maryland

21 BIRD'S-EYE VIEW OF
LEXINGTON MARKET
Library of Congress
LC-D401-16538

Printed in the USA
CPSIA information can be obtained
at www.ICGtesting.com
JSHW072023140824
68134JS00042B/3757